max ernst

max ernst

Giuseppe Gatt

Hamlyn
London New York Sydney Toronto

twentieth–century masters
General editors: H. L. Jaffé and A. Busignani

© Copyright in the text Sadea/Sansoni, Florence 1968
© Copyright in the illustrations SPADEM Paris 1968
© Copyright this edition The Hamlyn Publishing Group Limited 1970
London · New York · Sydney · Toronto
Hamlyn House, Feltham, Middlesex, England
ISBN 0 600 35926 3

Colour lithography Zincotipia Moderna, Florence
Printing and binding: Cox and Wyman Limited
London, Fakenham, and Reading

Distributed in the United States of America by Crown Publishers Inc.

contents

List of black and white illustrations

List of colour illustrations

An eccentric Surrealist

Any critic examining Max Ernst's work and career is faced at the outset with the important question of the extent of the artist's participation in the Surrealist movement. What are his connections with self-declared Surrealists, and is it in fact possible to define him as a Surrealist? This is not a value-judgement; rather it involves looking beyond the confines of his artistic personality to the background of its development, to the most important avant-garde movements of the first half of the 20th century in Europe.

An over-simple explanation for the existence of elements in Ernst's work that are quite foreign to Surrealism is implied in the statement: 'Ernst is a master, and like all masters in the field of art, he isolates himself and observes only those rules which he himself has created.' But this is an idealistic art-historical interpretation. Not only is it limiting and for the most part inapplicable, but it also distorts the meaning of Ernst's work, which often shows itself to be compatible with Surrealist theories and Breton's ideas. It also fails to take account of the fact that Breton never regarded his ideas as constituting a finite statement—a view confirmed by the complex and often contradictory ramifications which stemmed from the original manifesto. One must also avoid falling into the error of some current interpretations of Picasso's work, which regard the artist as a creative agent independent of concurrent styles. In the case of Picasso, this view sacrifices the interpretation of his personality as one whose insatiable appetite assimilates not just one, but many styles—I would almost say all the most exciting styles of the avant-garde.

Looking at the subject in this way, it will be necessary to disregard all foregone conclusions in an attempt to reconstruct the essence of Ernst's art from the concrete values which are patent in it. The initial problem in this study will thus be the question of his relationship to and participation in the Surrealist movement. René Bertelé, introducing the selection of Max Ernst's works which won the first prize for the artist at the XXVIIth Venice Biennale in 1954, claimed that 'the names of four artists dominate Surrealist painting: those of Max Ernst, Joan Miró, Yves Tanguy and Salvador Dali. And one ought to add a fifth, that of Giorgio de Chirico (if one takes account of his painted work from 1910 to 1930) and a sixth, that of Marcel Duchamp . . .' If then Ernst is rightly numbered among the Surrealists, a comparison of his pictorial style with those of the other protagonists of the movement will make us realise that, in spite of his connections with it, his involvement in the movement is not total and is characterised by a wider ranging technical ability and a more independent imagination. It is well known that Dali and Tanguy (to these examples we could equally well add the names of other key figures in Surrealism, such as Magritte, Delvaux and to a certain extent

André Masson), while adopting the most varied subject matter, pursued essentially traditional techniques in their disturbing Surrealist representations of the subconscious dream world. Even where the forms they represent draw on the fantastic, their creations do not achieve formal innovation; the emphasis is on content, not form. For Miró it is different in that he is able to create new forms through the medium of the dreams of the memory. But it is nevertheless true that these are exercises in the development of an emblematic cypher that remains unchanged from the moment of its discovery.

It is characteristic, however, of Ernst (within the scope of Surrealist subject-matter – dreams, reversals of meaning, ancestral memories and the world of the unconscious) to pursue continually, and through far-reaching experiments in technique, a new formal language which would provide a whole range of new images – a fact more important than any thematic repetition or language of forms. So while Surrealist imagery showed itself through its principal champions to be capable of an immeasurable cultural achievement in treating subject-matter – dreams and the unconscious – that was unexplored and still only partially fathomable, in the hands of Ernst it reached for the historical problem of painting seen as an instrument for the understanding and interpretation of the world.

The logic of dreams

So far as the subject-matter and its origin are concerned, the external characteristics of Ernst's work are its ostentatious exploration of psychology, its preoccupation with the unfathomable depths of the irrational and the unconscious, and its air of disturbed enchantment and fantasy; it is a world in which man is a stranger, an impotent observer rather than a participant. It is a world in which the history of mankind has been wholly erased by a cataclysmic event in the universe (*Europe after the Flood* is the title of a painting of 1940–42) or by a conscious act of revolution which has destroyed everything.[1] On the other hand it can also be analysed from a historical standpoint and with a more humanistic interpretation – precisely by reason of the involvement of human experience in a totally modern and even

Fig. 27

1 It is worth recording that in May 1925 Paul Eluard, Ernst's best friend, wrote of this radical mental attitude, which sought to destroy all culture that was inherited or not the result of personal experience, as if it was a sort of sclerosis in Western society: 'There cannot be total revolution but only permanent revolution. Like love, it is the fundamental joy of life'. From other sources too we know of Ernst's enthusiastic and active participation in the 'destructive' side of Dada: among other things, he participated in the Dada 'event' at the Winter beer house in Cologne. Russell published a fascinating account of it, of which an abbreviated version follows. The aim of the demonstration was to overthrow contemporary taste and to create a new relationship between art and society. It took the form of a sort of 'happening' (forty years before their time) which was prepared by Ernst and Baargeld with the assistance of Arp, who was an experienced agitator. The exhibition was intended to be a sort of *Putsch* against society and against the conventional form of exhibition: visitors were encouraged to destroy a work of Ernst's with an axe that was part of the painting itself. The organisers' intention was not to make a gallery exhibition or show the paintings in a decorous manner, but merely to embarass and provoke the public. The catalogue quoted Max Ernst as the author of a statement which ran roughly as follows: 'It is not true what the newspapers say, I have never made use of gastric reflexes to increase the luminous quality of my paintings, I only use "belching tweezers".' Apart from work by Ernst, Arp, Baargeld and Picabia, the exhibition also included items by a 'common amateur' not otherwise identified. The catalogue names four sculptures and four reliefs by Ernst, with somewhat provocative titles, such as *Erectio sine qua non*. Ernst had designed the poster for the exhibition. To reach the gallery where the works were hung, one had to pass through the beer house lavatories, while a young girl dressed as a communicant stood by the door and recited lewd poems. The works were nailed to or leaning against the wall, while some had been thrown on the ground. One of Baargeld's pieces aroused great excitement – a sink filled with colour water in which there was an alarm clock, a ladies' wig and a wooden hand. None of these works exist any more; but the effects the exhibition had were excellent: it created a scandal in all quarters and was the reason for Ernst's final break with his father, whose last words to his son were 'I curse you'. A few days later, Ernst and Baargeld were summoned by the police and had to appear before a high-ranking official who shouted at them that they were a couple of cheats, impostors and scoundrels. Baargeld, not in the least overawed, replied that 'We are waiting for the matter to be dealt with by the Public Prosecutor'. The official then asked if he didn't want to know what the charges were, and continued by saying 'You are accused of fraud, since you have charged admission to an art exhibition that has nothing to do with art'. Max Ernst immediately retorted 'Not at all: we said expressly that this was a Dada exhibition. Dada has never claimed to have any connection with art. If the public mistakes Dada for art, that is not our fault'. In spite of this, the exhibition was closed for 'obscenity'. But when it came out that the 'obscenity' was limited to Dürer's engraving of Adam and Eve, which was incorporated in one of Ernst's sculptures, the police ban was lifted, as was the charge of advertising a brothel for homosexuals. The exhibition was opened anew, and the fact was announced in posters which took the line 'The exhibition which was closed down by the police opens again. Dada is on the side of law and order'. Not unexpectedly, the posters were confiscated by the police (Cf. John Russell, *Max Ernst*, Cologne, 1966).

8

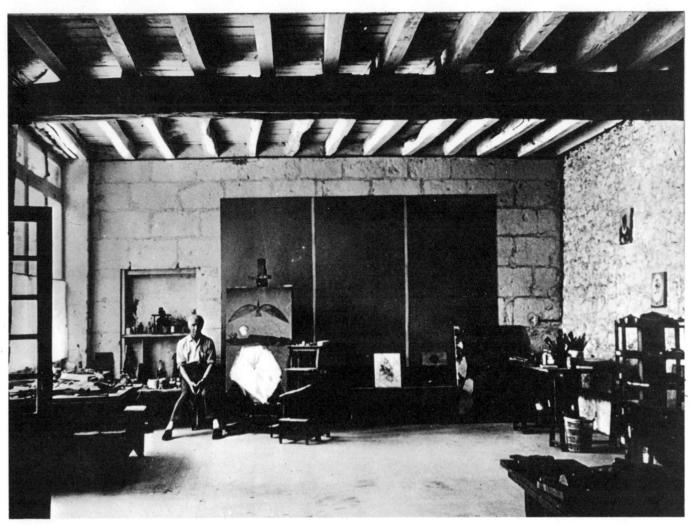

technological world, whose implications do not cause the artist to step back in horror. Thus we find side by side an imagination that is drawn towards a dream world, towards the most deranged states of mind, and a critical conscience that sees the need to control and comprehend the meaning of every step in this disturbing experience. Perhaps for this reason the most meaningful side of Ernst's work is contained not in playing on the theme of anguish nor in a repeated revolt, but rather in the continued search for meaning in man's world and in his activities. The impetus for this may not be a rational one, but it does present analogies with the attitude and concept of 'nécessité centrale' advanced by Antonin Artaud, who of all the Surrealists was perhaps the most concerned for genuineness in expression.

This dual character of Ernst's work provides an understanding of the dilated motifs to be found in his subject-matter, and of his obsession for a reality, inverted and illogical although in itself surprisingly 'convincing', which presupposes an important relationship between man's consciousness and the essence of the universe and creates this 'suspended' zone, deprived of all acquired characteristics and logical form, and fitted only to give shape to a personal interpretation. It is the logic of dreams and it works outside a rational framework, moving from subject to subject by the association of ideas and continual references of meaning. One can also comprehend the particular importance the idea of 'automatism' had for Max Ernst; indeed it is one of the keystones of Surrealism. For Breton, who used this method but rarely in his poetry, automatism belongs exclusively to the realm of psychics; through communication, whether spoken or written, it is able to transmit the real functioning of mental processes, no longer conditioned by the usual and artificial limits imposed by the will and conscience, but instead free to reveal its spontaneous form and action. In practice, this concept coincides with that of Surrealism and overlaps on to it; Breton in fact defined Surrealism as 'Pure psychic automatism by which it is intended to express, either verbally or in writing, the true function of thought. Thought dictated

1 Max Ernst in his studio with *Après moi le sommeil*

9

2 *Paysage et soleil*
1909, oil on cardboard
6¾ × 5¾ in (17 × 14·5 cm)
Author's Collection

in the absence of all control by reason, and outside all aesthetic or moral preoccupations.' 'Surrealism is based on the belief in the superior reality of certain forms of association hitherto neglected, in the omnipotence of the dream, and in the disinterested play of thought. It leads to the permanent destruction of all other psychic mechanisms and to its substitution for them in the solution of the principal problems of life'.[2] Now since this concept borders on the worlds of the dream and the somnambulist, and as soon as these manifestations take place in the more intimate and less accessible domain of the individual,[3] it is easy to comprehend the place which Freudian psychoanalytic theories could have had in them. These theories are known to have been important for Surrealist ideas, and Breton himself was aware of them directly, at least through his studies in medicine and psychiatry.

In this connection, we should bear in mind his passionate defence of the extravagance of the Surrealist Manifesto: '. . . Everyone knows, indeed, that the demented owe their internment to a small number of reprehensible actions and that without these, their liberty (what can be seen of their liberty) would not be put in doubt. I am ready to admit that they may be victims of their imagination—I mean that in the sense that it drives them not

2 Cf. *Surrealism,* by Patrick Waldberg, 1965, p. 72.
3 Surrealism makes solitude—of the social kind but more especially spiritual—a condition for genuine freedom, a realease from the conventional that inevitably establishes itself in a dual or communal relationship.

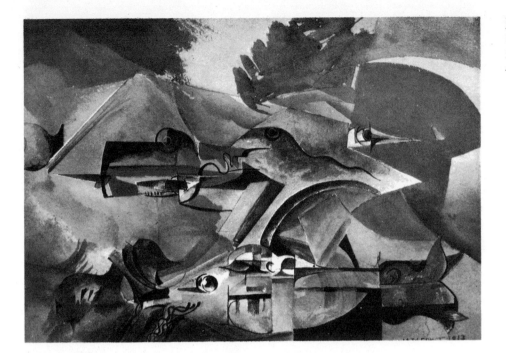

3 *Combat de poissons*
1917, watercolour on paper
$5\frac{1}{2} \times 8$ in ($14 \times 20\cdot5$ cm)
Author's Collection

to observe some laws outside of which the race feels injured, a fact which every man has known to his cost. But the profound detachment which they show in their attitude towards our behaviour as it affects them, and even to the various punishments which are inflicted upon them, prompts the belief that they may have found great comfort in their imagination, and that they gain enough pleasure from their fate to bear that it should be their fate alone. For this reason hallucinations and illusions, etc., can be a source which should not be ignored'.[4]

The image prompts the dream

Ernst's 'automatism', on the other hand, is generally of the genre of chance–taking the form of the sudden and exciting recognition of forms and images that were not altogether anticipated. Thus the images formed in this way are not the products of a disturbed consciousness or of a dream state of mind; they themselves provoke hallucinations and mental responses by mysteriously altering the visual meaning of things. They are endowed with their own predetermined form, but they are not set in a space disposed by conventional means (unlike Dali and Magritte who are happy to employ Euclidean geometry and traditional perspective). Rather they depend on their own inherent inventiveness and capacity for continual change, employing technical innovations whose possible effects the artist himself cannot foresee. *Frottage* is combined with figurative forms, perfect reproduction with altogether free form, straight lines with curved and sinuous ones. This continual autonomous mixing and combining of the forms and their overlapping explains the transformation of the image, which may transpose itself from the animal to the vegetable world, from the geological to the mechanical.[5] In his experiments with form Ernst is an indefatigable worker, as tireless as Picasso, as strict as Klee. The element of chance is made to coincide with a perfect figurative balance and with the completeness of the image; and only when the work has reached a conclusion within itself in the course of its slow autonomous growth can the process be regarded as complete. In this way the dream does not determine the image, but rather the image prompts the dream. Ernst does not abandon the image when it is complete–he dreams and entrusts himself to it after having fostered it and brought out its potential. Ernst himself declared, in 1936, that after the discovery of the technique of *frottage* he played a spectator role in the creation of his works. From his youth onwards he would answer queries as to his favourite occupation with the answer: 'seeing'.[6]

4 Quoted from *L'Arte Moderna*, Milan, 1967 (Vol VII, p. 365).
5 See for instance *The Origin of Chestnut* from the *Histoire Naturelle* series.
6 See the autobiography, p. 92.

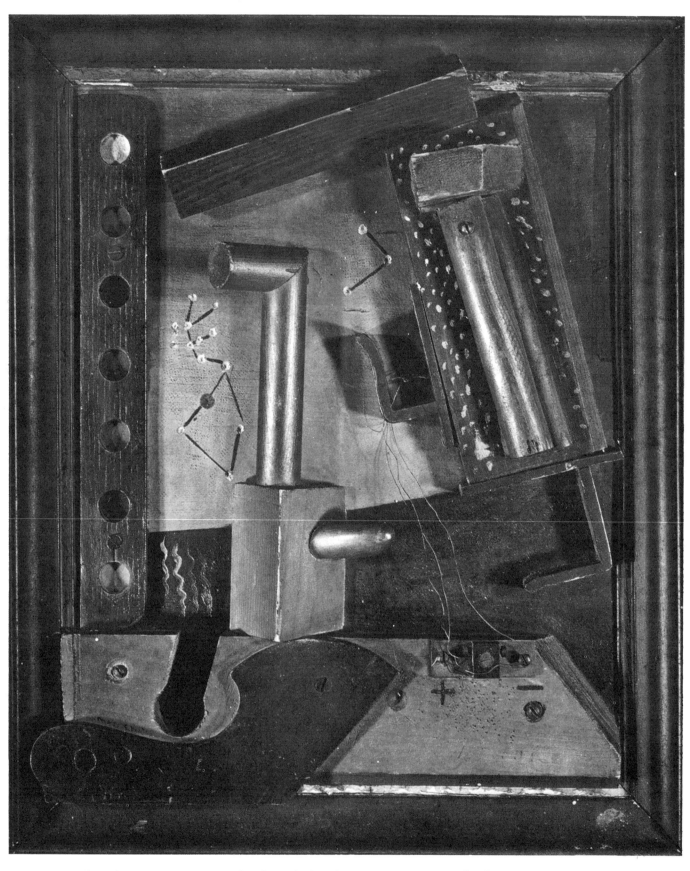

4 *Fruit d'une longue expérience*
1919, relief, partly painted with
pieces of wood and iron wire
18 × 15 in (45·7 × 38 cm)
Sir Roland Penrose Collection,
London

So the painting is not a passive record of an event or a movement in the psyche, but a means to an end, an instrument of research in the quest for an understanding of the world. Ernst shows himself here once again as a bearer of the German spirit of Novalis and Hölderlin, Kant and Freud, Nietzsche and Einstein, in which the 'rational' and the 'irrational' appear as complementary arguments, neither of them at any time wholly eliminable.

Ernst's use of automatism in his imagery reveals his own irrepressible consciousness of what is vital and organic, and demonstrates his participation through his art in a creative process (André Pieyre de Mandiargues later said 'a world that is perceived, grasped in the very moment of creation'). Through this creativity his very down-to-earth awareness (which dominates

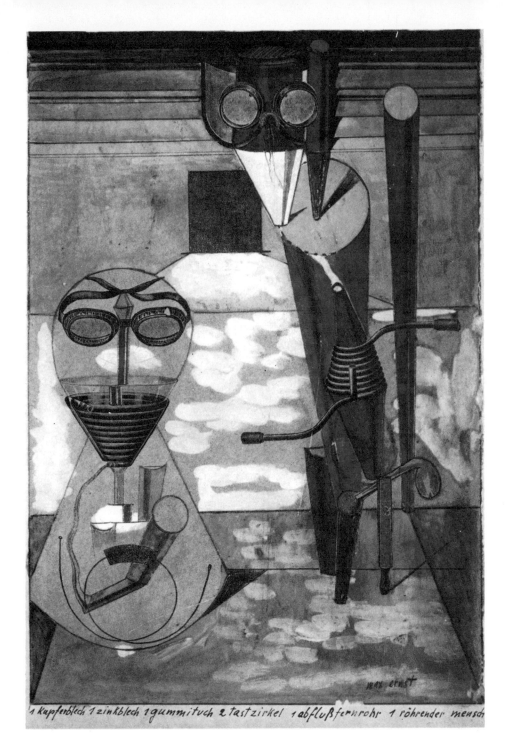

5 *Two ambiguous figures*
1919–20, collage and
gouache on paper
$9\frac{3}{8} \times 6\frac{1}{2}$ in (24·2 × 16·7 cm)
H. Arp Collection, Meudon

all his explorations) enhances rather than diminishes contact with the real
world, thus introducing a new rapport in terms of space and time (even
though we are here dealing with interior space and time in terms of memory,
suspended in a sort of limbo).[7]

We have spoken of the fact that Max Ernst's technique results in images that
go beyond the limits of his intentions (this is the most evident result of his
automatism) and which themselves become objective to the extent of
maintaining an equal and parallel existence with the objects and processes
of nature. In its development from Cubism to Concretism, and the Surrealist
equivalent in the abstractions of Klee and Kandinsky, abstract art is different
from Surrealism in that while abstraction presents the work of art as a
thing or object of reality, Surrealism presents it as another reality, or more

Art as surreality

7 In *Au delà de la peinture (Cahiers d'Art,* 1937) Ernst described the birth of *frottage:* 'On the 10th
August, 1925, an overpowering visual obsession led me to discover the technical means which allowed
me to make a broad interpretation of Leonardo's teachings. Starting from a childhood memory in
the course of which a false mahogany panel facing my bed played the role of optical *provocateur*
in a vision of near-sleep, and finding myself one rainy day in an inn by the sea, I was struck by the
magnetism exerted upon my excited gaze by the floor – its grain accented by a thousand scrubbings'.
Cf. also the autobiography, p. 94.

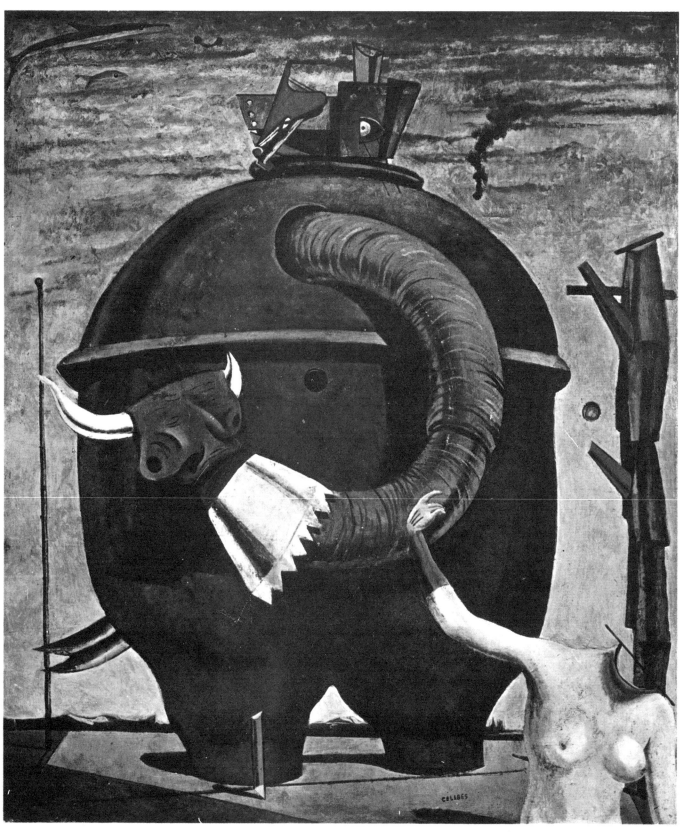

6 *The Elephant of the Celebes*
1921, oil on canvas
$51\frac{1}{8} \times 43\frac{1}{4}$ in (130×110 cm)
Private Collection, London

properly as a 'surreality'. This does not mean that there is no exchange with reality itself. In the less ambiguous and contorted instances of Surrealism (here one would include Ernst), the artistic process is an act of existence and achieves its development in time and space, directly in contact with the world of experience. In contrast to Dali and Delvaux, who employ perspective as the sole spatial dimension, accepting the limitations of the three-dimensional presentation of the Renaissance tradition, Max Ernst breaks up his space in a variety of emphases that has no parallel even in Cubist imagery (nor perhaps in the work of any contemporary artist). When it is presented in a perspective form or in terms of atmosphere, Ernst's space is never a background to set objects off, but rather plays an active role in the articulation of the image.

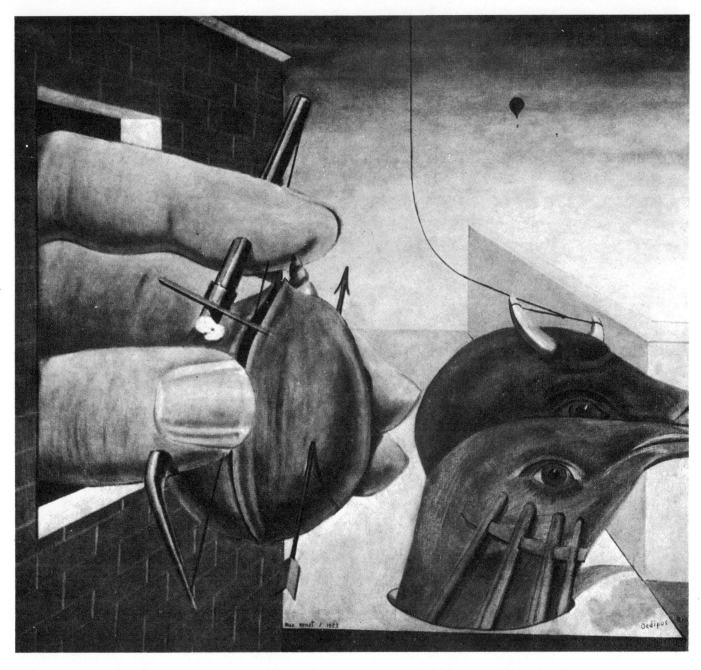

This penetration into the silence of an untainted Nature, almost at the dawn of the world, is a transference which on a conscious level implies a reassessment of the incipient consciousness and its initial wonder at the world; from this point it turns towards a re-organisation of it. Ernst's narrative does not take him up the blind alley of the myth;[8] rather it starts again from the beginning, describing that 'future continent' of which Breton writes, where Man will be wholly freed from all limitations—first of all from that of logic.[9] Ernst's elementary forms are certainly beyond the realm of the figurative, or rather they prefigure something outside it; they are shown in such a way that it seems as though their author is using the

7 *Oedipus Rex*
1921, oil on canvas
$36\frac{5}{8} \times 40\frac{1}{4}$ in (93 × 102 cm)
Private Collection, Paris

8 It should also be noted that the 'old' figurations used in collages have no meaning for Ernst; his are the result of a genuine obsessive visual 'irritation' which pleases and enslaves the sight at one and the same time.
9 Interest in the modern world in all its aspects and anxiety for the future of man are typical of Surrealism, and indeed show the extent to which Dada had been left behind; for the latter was always exclusively involved in the immediacy of the present, with a totally nihilistic philosophy that had no concern for the future of the world. The abandonment of this stance is noticeable in Max Ernst's work after 1920. In the same year, Jacques Rivière published his *Reconnaissance à Dada*, which also illustrates a move beyond the Dada attitude and a natural progression towards Surrealist thought: '. . . What do the Dadaists show in fact, apart from the fact that through their activity it is not impossible to create something, and that extroversion on its own results, at least for the writer, in complete abdication? Seeking the way out, working to one's own ends, means a fatal abandonment of artistic preoccupations and the idea of will on an aesthetic level. The Dadaists point out that Max Jacob's formula, "to give vent to one's extroversion through selected means", implies a contradiction in method. To "select" the means which one is to use involves an imperfect, distorted inter-

15

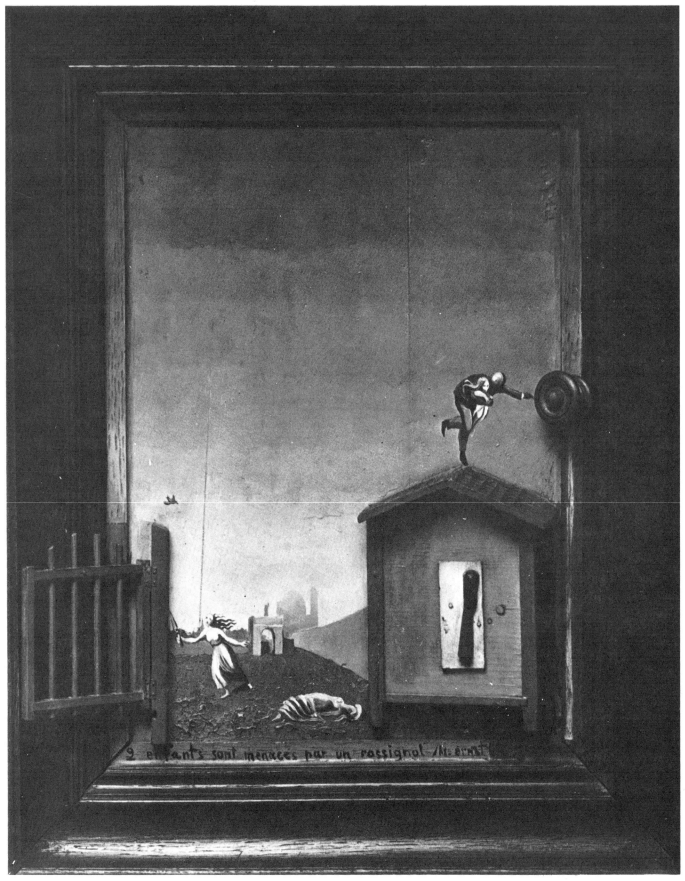

8 Deux enfants sont menacés par un rossignol
1924, oil and wood
$18\frac{1}{8} \times 13$ in (46 × 33 cm)
Museum of Modern Art, New York

pretation—one would be lying to oneself. Thus whoever has set as his goal a full self-expression must reach a point where the work of art, indeed any work, is unacceptable and intolerable . . . A literature like ours which has been centrifugal for almost the last hundred years implicitly involves a conclusion outside the field of literature. So in its abstract, negative and extrovert characteristics, Dada represents in a complete form what had been the implicit dream of many generations of writers . . . Every word that stems from inside the mind expresses it, for nothing but its own impulse provoked its appearance, even though it may be comprehensible. Every word is justifiable and expressive, in whatever sequence or context, for it serves to reveal something. On this point too the perception of Dada was profound and correct. On this point too it was right, finally reaching a linguistic void just as it had already come to a psychological void . . . The conclusions which the Dadaists drew from their guiding principles seem to me to be unavoidable. We must therefore change these principles. We must give up subjectivism, effusion, pure creativity, the translation of the ego and that constant disregard of the object which have driven us into the void. . . .'

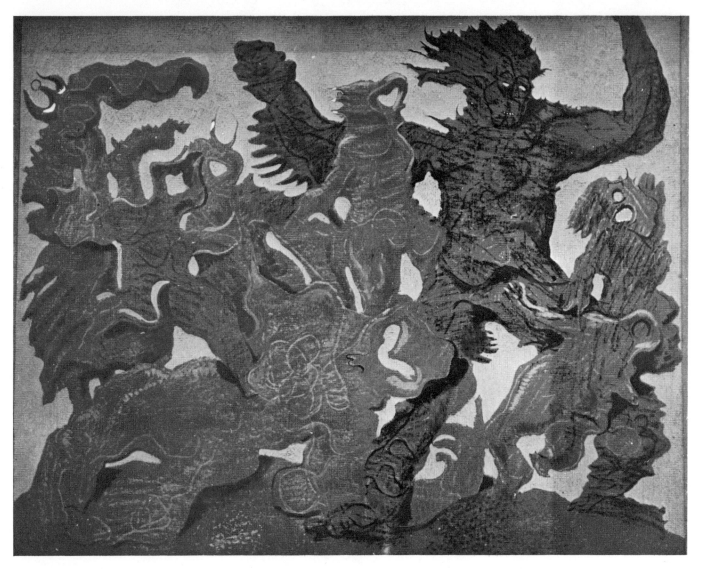

9 *The horde*
1927, oil on canvas
$44\frac{7}{8} \times 57\frac{1}{2}$ in (114×146 cm)
Stedelijk Museum, Amsterdam

particular representational technique for the first time. While Ernst pursues the elementary character and ultimate form of human existence, his underlying tendency towards the compositional is ready to echo the world more directly, to create open and readable compositions, in other words to make a narrative.

At first sight Ernst's work seems to be removed from a historical context, and to exist in a sort of neutral time – like time in memory or in dreams. But although we might concede that this was the intention, he nevertheless absorbed contemporary ideas and they find a place in his work. But they are absorbed into his cultural background and thus do not show through as a day-to-day concern, a need to keep up with the avant-garde. To find some examples which clearly illustrate this we need only turn to some of the high points in his artistic career: stark geometrical forms reappear apparently haphazardly throughout, both on their own (*Paris rève*, 1924; *La mer et le soleil*, 1927; *Une belle journée*, 1948), and mixed with organic material (*Mer et soleil*, 1924; *Radeau*, 1927; *Ville*, 1933), or developed into an imaginary form (*Oiseau et océans*, 1954; *Don Juan et Faustroll*, 1957). Spatial effects, not without Cubist influence, are found in *Les noces chiminques*, 1947; *Exercice de style*, 1913; *Combat de poissons*, 1917. The use of several materials in collages and other characteristics show his attachment to Dadaist techniques. We find, too, sudden deepenings of the consciousness, which cause the external to coincide with the internal world.[10] The arrangement of some of his images (such as *La mer et le soleil*, 1929) recall the synthesis that Tapiès achieves, while his more recent work (*Léonard de Vinci*, 1956; *Eclosion*, 1957) is more abbreviated and emblematic in style, and takes up the idea of autonomous growth, originally made possible through *frottage*,

Fig. 3

10 *Complainte*, of 1929, forestalls the abstraction of Wols in its graphic style and that of Gorky in its presentation of a definitive image.

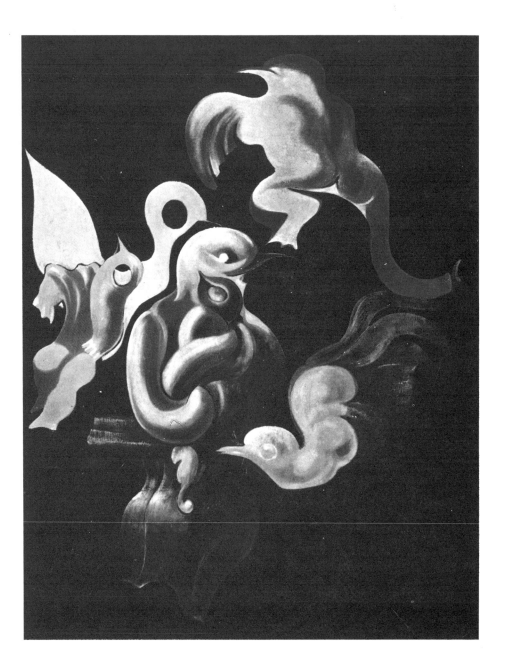

10 *Après nous la maternité*
1927, oil on canvas, $57\frac{1}{2} \times 44\frac{7}{8}$ in
(146×114 cm)
Kunstsammlung Nordrhein-
Westfalen, Düsseldorf

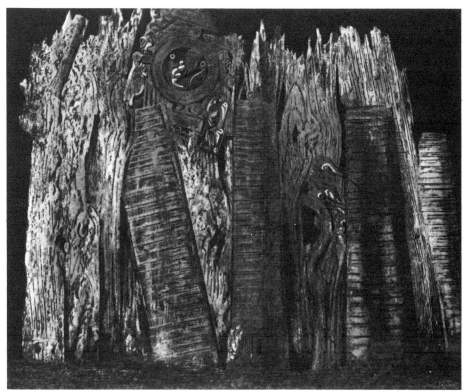

11 *Vision provoquée par l'aspect
nocturne de la Port Saint-Denis*
1927, oil on canvas
$26 \times 32\frac{1}{4}$ in (66×82 cm)
M. Mabille Collection, Brussels

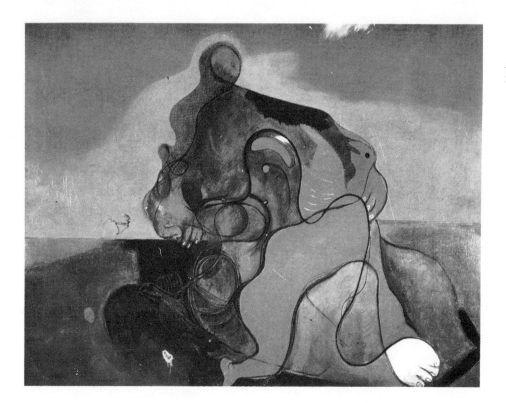

12 *The kiss*
1927, oil on canvas
$50\frac{3}{8} \times 23\frac{5}{8}$ in (128×60 cm).
Peggy Guggenheim Collection,
Venice

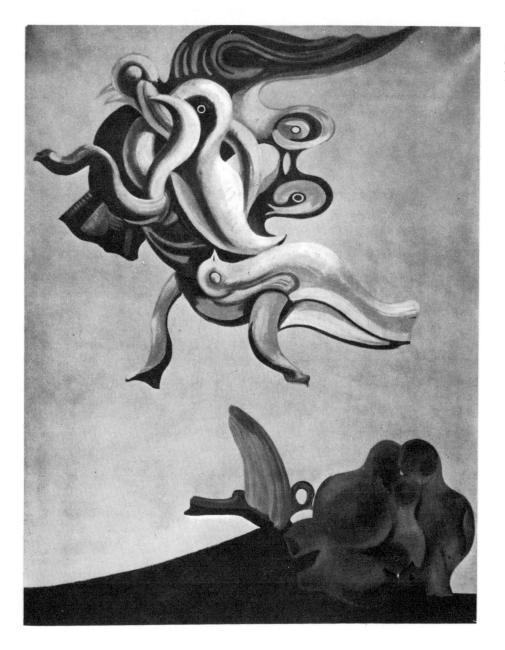

13 *Monument to the birds*
1927, oil on canvas
$63\frac{3}{4} \times 51\frac{1}{8}$ in (162×130 cm)
Private Collection, Paris

14 *Family*
1928, oil on canvas
$38\frac{1}{8} \times 51\frac{1}{8}$ in (97 × 130 cm)
Private Collection, Basle

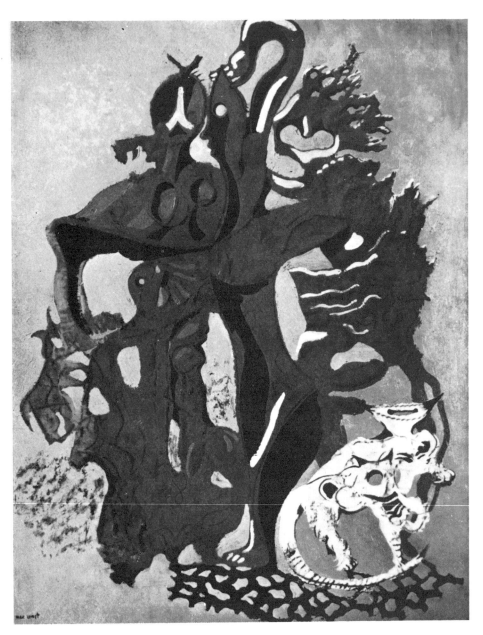

in an abstract key. Then we come to the better-known Ernst – the painter of 'hordes', 'zoomorphic couples', 'brides of the wind' and the 'myths' which can be deciphered in the Leonardoesque depths of damp green blotches (*L' Europe après la pluie*, 1940–42; *La Nuit Rhénane*, 1944; *La Nymphe Echo*, 1936) or the slimy horror of sensuous desert landscapes such as those of *Le miroir volé*, 1939; *Nuit claire*, 1942; and *L'œil du silence*, 1944.

Pls. 18, 26 Fig. 9

Figs. 27, 25

Fig. 29

The blind navigator

Ernst's art thus stirs an awakening consciousness, plumbing the depths of the soul and plunging it into a universe which is animal, vegetable and mineral but whose existence is founded on no *a priori* conceptions. Its discovery dates from the moment of its creation, on a voyage of discovery with a blind navigator at the tiller. The implications behind his painting are a rejection of the past in terms of authority, of the present as one of action and dedication, and the formation of a dimension of time which offers vital potential that can only be grasped through the unfolding of a germinal, embryonic life, continually changing and developing in unforeseeable ways. The difference with Miró is that the latter remains in the embryonic stage of that life without proceeding to a more developed phase, while Klee stands outside considerations of time and space, identifying the present as the supreme act of existence. Ernst on the other hand participates in the creation of reality, even though his reality takes place in a dimension which is outside the normally accepted concept of reality. His creativity is akin to biological cycles, natural growth or spontaneous germination.[11] While on the one hand he rejects history as a representative human structure, on the other he

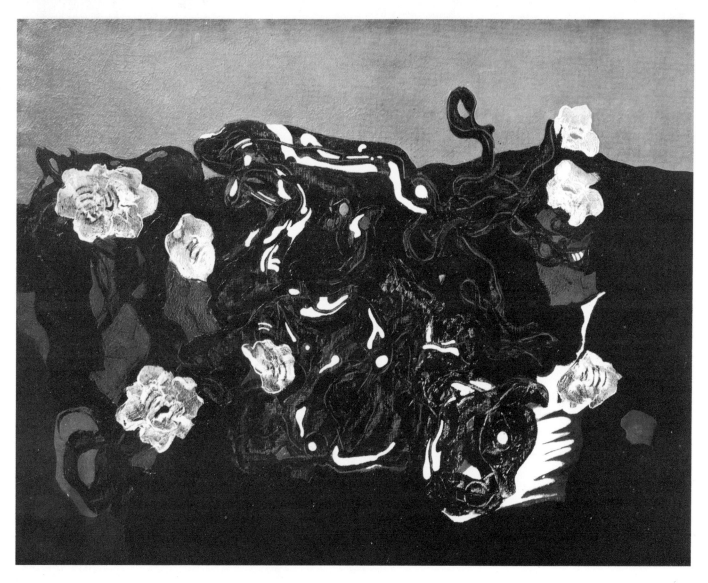

uncovers a world which is a projection of man and which only through the medium of his artistry is made vital and full of meaning. And he also makes the discovery that the condition of man is an unhappy one, for man has held to be real what turns out to be merely a symbol, an accepted literary figuration which in fact has deprived man of his real place in time and space.

The development of Ernst's figurative style is a record of this attempt to find such a place, and since there are indeed no firm points of reference, the journey of this pale and desperate helmsman is indeed 'blind', full of unexpected turns and adventures. And when, in the course of this journey, one comes upon shores that are totally unknown, then all is still, with a blood-chilling silence, and the only certainty is the clear knowledge of being in an unknown place.

So the journey to the depths, to the infinite and the unknown realms of existence, is an opportunity for revelation, for gaining an understanding of what had previously been buried in the irrational. This is the most genuine message of Surrealism; the same journey to remote and deserted regions brought Rimbaud to the fantastic visions of his *Bateau ivre,* and Lautréamont ('the apologist of evil and desperation') to the feverish rebellion of seeing imagination and fantasy as the supreme act of existence. These are all 'wanderings of the human spirit', to which Breton[12] was to attribute the power to penetrate the underlying meaning of life in the 20th century without rejecting any scientific, technical or ideological assistance which

15 *Le rendez-vous des amis— Les amis se changent en fleurs* 1928, oil on canvas $51\frac{1}{8} \times 63\frac{3}{4}$ in (130×162 cm) Private Collection, London

11 It should be noted that there are many references in Ernst's work to creatures of the sea and to water seen as a place where life germinates spontaneously: 'Were we our ancestors/a lump of mucus in a warm pond,/Life and death, fertilization and generation/would slip from our dumb juices . . .' wrote Ernst's compatriot Gottfried Benn.
12 When Breton wrote *Existence is elsewhere,* he recalled Rimbaud's contention: 'Real life is absent, we are not in this world'.

might provide a broader and deeper comprehension of the connections and hidden associations between man and reality.

If we now compare Ernst's version of reality with the principles of Surrealism that can be deduced from the 1924 Manifesto,[13] we can see the points of contact and also the difference in their separate approaches. It is clear that Ernst accepts Breton's anthropological definition of man as a 'definitive dreamer' only on the understanding that the existence in man of a critical capacity on a historical level should also be recognised. This is completely foreign to an artist like Dali, who – despite Breton's 'excommunication' and the unreasoned condemnation of him by many contemporary critics – is still a strictly orthodox Surrealist artist, both in his working methods and in the results he produces. Like Breton, Max Ernst denies the value of history as a standard ('man . . . knows the laughable course of events that are the background to his formation'), but he accepts it as the dimension of time in which man finds himself. Thus he rejects the idea of infancy as the only possible state of innocence, and also the notion that a clinical state of madness is a *sine qua non* for freedom. In short, Ernst uses art as a means of exploration into the surreal and fantastic, evaluated by the critical consciousness which follows the creative phase. While the power of the imagination (exalted by Breton) is indispensable at the moment of creation, it is no longer the only factor when the work of art enters – assuming its traditional function – into the realm of consciousness, for here it no longer stands in isolation but involves relative and circumstantial considera-

13 One should however bear in mind that this Manifesto is far from being comprehensive about the nature and style of the movement, although it illustrates its extrovert style well. Breton's manifestoes are also well known for their literary style, which displays a very refined and precious employment of the French language.

17 *Intérieur de la vue – L'œuf*
1929, oil on canvas
$39\frac{3}{8} \times 31\frac{7}{8}$ in (100 × 81 cm)
R. Thurman Collection, Boston

tions. Ernst, who makes no attempt to observe logic – indeed he dispels it
from his mind – nevertheless presumes to define the illogical. It was Breton
who wrote 'One has to be very self-confident to want to set foot in those
remote regions where everything has the appearance of being difficult'.
Ernst's stay in those regions was, however, only a temporary one; he may
have made repeated excursions there but showed no desire either to set up
residence or to play the game of the *Cadavre exquis*[14] – which for Breton
provided the means for immobilising one's critical faculties and giving free
rein to the metaphysical activity of the mind – to the extent of regarding it
as a wholly acceptable and always valid method. But on the other hand these
differences are possibly due to the very nature of painting itself; in this
instance it is no chance that Breton's manifesto only mentions the names of
Crevel and Desnos as painters, and they are better known for their activity
as mediums than for their painting.

Ernst's work thus depends in part on inherent contradictions; it is dream-
like and unconscious, but it also reflects existence and reveals a critical
consciousness fully aware of comparative values. This is true in so far as the
dream is never used to the fullest extent by Ernst as an instrument of revela-
tion.[15] There is a place in it for irony, so that the artist can use it as a liberating
game that is entirely controllable, on the brink of consciousness as well as

14 *Cadavre exquis* is a game played with a piece of folded paper. It consists in making a sentence or a
drawing collectively among a number of people without any one of them being able to know what
the previous person or persons have written or drawn. The first phrase that was achieved through
this method became a classic example, and gave the game its name: 'The exquisite-corpse-will-drink-
the-new-wine'. Cf. *Arte Moderna* cit., p. 371.
15 Ernst has shown, autobiographically as well as in other ways, that dreams are not reliable.

18 *Gala*
bronze
$15 \times 9 \times 6\frac{3}{4}$ in $(38 \times 23 \times 17$ cm$)$
A. Susse Collection

beyond it. Goya's dictum, that the 'sleep of reason produces monsters', is never accepted, but neither is it wholly rejected.[16] The irrational, the obscure and the inascertainable are themes whose outcome is determined at that very moment when a feverish mind, penetrating the unexplored realm of a desperate and hallucinating solitude, evokes and recreates them, even through the risky element of chance, from the indistinctness of an unknown and unconscious dimension to the vital proportions of entities that shape and form themselves through constant metamorphosis.

Totem-like sculpture

Pls. 18, 29–31, 17, 34, 26
Figs. 9, 32

Without a doubt the ideas advanced so far are most easily verified in Ernst's sculpture. Here the element of automatism is virtually excluded, and another feature common to most of the artist's work is also absent – the spontaneous growth forms, the organic element which suggests the natural, human, and animal forms of the 'feather-flowers', the 'hordes' and the 'forests'. In fact, despite the disparate exploitation of formal compositional links and the common anthropomorphic form of the creatures Ernst creates, his sculpture pursues values that are spatial and rhythmic rather than connected with the image. The development is in part comparable to that of Arp and Giacometti, but with an emphasis on structural qualities and a noticeable lessening of the organic and existential properties that charac-

16 Cf. Lorenza Trucchi (*Max Ernst – Un romantico dopo Freud, Momento Sera*, 5–6 July 1966), who however thinks that Ernst arrived at a reversal of Goya's meaning, in connection with the painting of *The Sirens singing while Reason sleeps.*

terise the latter artists. It is clear that no parallel can be drawn between
Ernst's 'construction' and Constructivist ideas, for his art relies on the
'holding' of individual gestures and subsequent elaboration from those
forms–a method which can be compared with Julio Gonzales' 'construc-
tion'. It is to this that Ernst's figures owe their vitality, and at the same time,
this is the reason for the persistence of figurative forms.

Thematically, Ernst's sculpture has something in common with the totem.
This implies his desire to avoid organic forms and spontaneous modelling,
so as to fix the image in a finite form which denies even the possibility of
metamorphosis. What remains in terms of the 'imprecise'–and even this is
outside the context of sculptural modelling–is the feeling of magical and
symbolic power which these images radiate, and it is this that they share with
the totem.

The motives behind the assimilation of a primitivist vocabulary are
many. In figurative terms, it is a recognition of the rediscovery of the
'primitive' as an aesthetic standard in Europe–although this phase had
already come to an end in the work of Picasso and the Cubists–while on a
cultural level it inevitably recalls the work and thought of Freud and Lévi-
Strauss. Nevertheless, it is not often that Ernst's sculptures can be satis-
factorily explained as 'objects with a symbolical function' of the kind Dali
defined in 1931 as the incarnation and materialisation of the reality of the
dream. On the contrary, their forms are much more consciously controlled
than those of the paintings.[17]

20 *Loplop présente une fleur*
1931, oil and collage on wood
39 × 31⅞ in (99 × 81 cm)
Galerie Le Point Cardinal, Paris

Figs. 18, 19 So the most individual characteristic of Ernst's sculpture is the objective quality of the forms, and it is not by chance that the organic plays so small a part in them that objects are often combined which do not link together but remain isolated by the very objectiveness of their conception. Examples which show these characteristics obviously include *Table set* (1944), *Lunar asparagus* (1935), *Two in one* (1955), *Capricorn* (1964), *Ninche* (1955–56). Each image possesses a complete meaning and significance which, while it is confined in space and time, expands mentally outside the physical limits of the form. For this reason, I do not share Lippard's[18] interpretation of Ernst's sculpture as having an organic background; although I would agree with her (and refer the reader to her) as regards her tentative interpretations of the sculpture in terms of Freudian and Jungian symbols.

Contradiction of the theoretical premises of Surrealism

For Ernst therefore (as indeed for all the intellectuals who took part in the Surrealist adventure) Rivière's prophecy came true: his works succeed best in precisely those instances where they most obviously run counter to orthodox Surrealism, whose productions—as Franco Fortini[19] noted in a

17 In this connection, it is interesting to note a remark by Argan on Surrealism in a book on Miró: 'Surrealism started from the basic premise that the conscious and the unconscious were objectively separate and antagonistic towards each other. It prized the liberty and the genuineness of the unconscious state, for it was here that psychological and social inhibitions had least play. So it is that the Surrealist unconscious is most often only a reproduction of the conscious in an ironical or paradoxical context, or a paradoxical reversal of values; and it is thus still consciousness, and it is still an act of the conscious to wish to place oneself outside that state'. (G. C. Argan, *Salvezza e Caduta nell'Arte Moderna,* Milan, 1964, p. 171.)
18 Cf. Lucy R. Lippard, *The Sculpture (of Max Ernst)* in the catalogue of the Max Ernst Exhibition at The Jewish Museum, New York, in March–April 1966.
19 F. Fortini, *Il Movimento Surrealista,* Milan, 1959.

study published ten years ago—'take on the dual character of a subjective judgement and an impersonal, pseudo-scientific record. Between these two extremes, in which can see an inheritance as much of the sentimentality and spiritualism of Romanticism as of Positivist Naturalism, what remains excluded from the Surrealist experience is the quality of history as a ground for the study of human and social relations, suppressed in the name of a greater directness, of immediacy and of complete revolt'. Max Ernst not only grasped the importance of this historical factor, but also—as we have attempted to show—made history himself. 'Time'—Fortini continues—'has made most of the Surrealist texts of "automatic writing" unreadable, and has treated Surrealist poetry in much the same way. There is no sadder prospect than those objects "with a symbolical function", the "object-poems" and the laboured creations of Surrealist painting and sculpture. The reason is obvious; these were creations that were intended for immediate consumption, not intended to last; they made no claim to be "art". Their power to shock and scandalise was conditional on the environment in which they were born. The works which do survive and still have a message are those which in some way betray the influence of a positive will, possessing intrinsic formal limits and so an intentional composition'.

Besides, one should not confuse the broadly based thinking of Breton with the ambiguous and opportunist attitude that many pseudo-intellectuals adopted in speculation on the premises of Surrealism, debasing its raison-d'être and distorting its genuine purposes. In this connection, it is once again worth noting what Fortini has to say on this subject: 'Quite a number

of Surrealists, especially those who described themselves as Surrealists, took up anything that would take them out of day-to-day reality, whether it was the narcotics which had been dear to Baudelaire, Rimbaud and Jacob,[20] or alcohol, or debauchery or vice. It should not be forgotten that for many years the Surrealists were surrounded by a large number of people whom it would be charitable to describe as eccentric, many of whom could well have formed case histories for a treatise on sexual psycho-pathology. And also, approximately from the date of Dali's appearance on the Surrealist horizon, there was a sort of patronage which favoured the adoption of overtly pornographic subject-matter. The luxurious review *Minotaure* was really a collection of photographs or of basically sadistic illustrations chosen from Cranach, Urs Graf, Botticelli, Géricault or modern painters, which went to the limits legally permitted in a medical textbook. It exudes a nauseous odour of snobbery and the Gestapo.'

Childhood development

Any account of the development of Max Ernst must cover a variety of factors, which include considerations of the geographical and political character of his birthplace, the nature of the culture in that region of Germany which, although it is noticeably influenced by France, seems so decidedly German, his family life, and especially the influence of his father, whose personality plays a key role in Ernst's life and to whose influence are

attributed many infantile complexes which form part of the artist's uncon-
scious and are often referred to in his work.

Max Ernst was born on the 2nd April, 1891 in Brühl, a small town south
of Cologne in a forested area on the banks of the Rhine. The history and
politics of the Rhineland have made it an area where the cultures of France

20 These individuals, however, showed an altogether different moral as well as artistic capacity in
the sacrifice of their own lives in a last, albeit desperate act of rebellion. Neither should it be for-
gotten that the position of Surrealism in its social context was not without harsh criticism. Jean-Paul
Sartre himself, writing in 1948 (*Che cos'è la letteratura,* in *Situazioni,* 1948) did not spare the movement
the most stringent criticism, which is most relevant in this context: 'Surrealism takes up anew the
destructive tendencies of the writer-consumer. These hot-headed young bourgeois want to destroy
culture because they have been educated by it; their principal enemy is still the philistine of Heine,
Prudhomme and Monnier, the bourgeois Flaubert – who in fact might as well be their father. But
violence over the years has brought them to radicalism. While their predecessors were content to
fight the utilitarian philosophy of the bourgeois by means of "waste", they are absorbed more into
the search for what is useful in human life, that is to say conscious existence. Conscience is bourgeois,
the I is bourgeois. . . . What is meant above all is the erasion of the usual distinctions between the
unconscious, between the dream-state and the waking-state. This implies the destruction of subjec-
tivity. Subjectivity in fact exists, when we recognize that our thoughts, our emotions and our will
come from us, when we perceive that they belong to us and at the same time that it is only probable
that the outside world is founded upon them. . . . The Surrealist has come to loathe the humble
certainty on which the Stoic bases his behaviour. . . . But the next step that the Surrealist takes is to
destroy objectivity in its turn. . . . It is an operation which cannot be attempted with something that
is real and thus has a character that cannot be distorted, so imaginary objects have to be created and
formed in such a way that they will themselves destroy their own objectivity. The basic pattern of
this method is shown by those fake sugarlumps Duchamp carved out of marble, which suddenly are
found out to be too heavy to be what they seem. The spectator who lifts them up is intended to

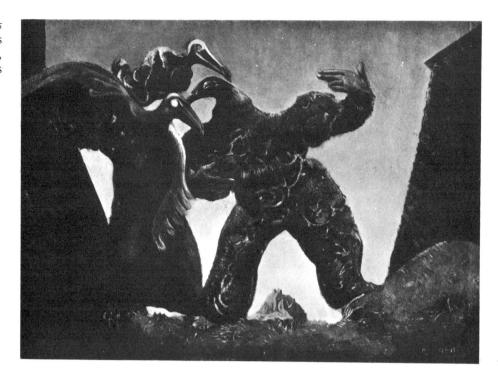

24 Confidences
1935, oil on canvas
Dorothea Tanning Collection,
Huismes

experience, in a sudden flash of understanding, the self-destruction of the essential objective identity of the sugar. . . . The world we live in, rendered null and void even without touching an ear of its corn, a grain of its sand or a feather of its birds, is simply "put in brackets". . . . The Surrealists, having destroyed the world and having preserved it miraculously by means of its destruction, abandon themselves without shame to their immense love of the world. . . . The core of the matter consists in the need to find for oneself, once more, an eagle's nest. . . . What these favourite children want to squander is not their family patrimony, but the whole world. They have gone back to being parasites as if that were a lesser evil, abandoning by common consent all studies and professions. But it was not sufficient to be the parasites of the bourgeoisie–they wanted to be the parasites of the whole world. However metaphysical it sought to be, their classlessness seems to have worked from the top: their interests have seen to it that they never have a public in the working classes. Breton once wrote: "Marx said–transform the world, and Rimbaud–change life. These two directives are one for us". This much would be sufficient to betray the intellectual. For it is a case of knowing which change should come first. . . . Nevertheless Surrealism calls itself revolutionary and extends its hand to the Communist party. . . . They would like to be the clergy in an ideal society, where their temporal function would be the continual exercise of violence. So, after having praised the suicides of Vache and Rigaud as exemplary actions, after having presented massacre ("emptying one's revolver on a crowd") as the Simplest Surrealist Action, they call for assistance from the Yellow Peril. They do not perceive the absolute contradiction between these brutal and partial acts of destruction and the poetical process of annihilation which they have proposed. Each time, indeed, that an act of destruction is partial, it is a means towards a positive and general end. Surrealism stops at the means, it makes an absolute end and goal of it and refuses to go further. So far as the Communist Party itself was concerned in those years, it was hampered by the arm of the bourgeois police, was numerically very much inferior to the Social Democrats Party, and had very little hope of direct power except as a possibility in the remote future. . . . It had to join forces with whatever elements it could separate from the majority that rejected it: its intellectual weapon was criticism. For this reason, it was possible to see Surrealism as a temporary ally, which could be set aside when it was no longer needed, for the negation that formed the essence of Surrealism was but a first step for the Communist party. . . . The link between Surrealism and the proletariat is indirect and abstract. The power of a writer lies in his direct effect on his public, in the indignation, enthusiasm or thoughts which he provokes in his readers. Diderot, Voltaire, Rousseau–these always maintained contact with the bourgeoisie because the bourgeoisie read their works. But the Surrealists have no readers in the proletariat: they can barely establish contact with the Party, from outside, or rather with the intellectuals of the Party. Their public is elsewhere, in the cultivated bourgeoisie. . . . The originality of the Surrealist movement lies in its claim to *everything,* all at once–classlessness from the top, a parasitic existence, the aristocracy, the metaphysics of consumption and the alliance with revolutionary forces. The history of this attempt shows that it was doomed to failure. But fifty years earlier, it would not even have been conceivable–the only contact that a bourgeois writer could have had with the working classes would have been to write for and about them. What made possible even the thought of such a temporary pact between an intellectual aristocracy and the oppressed classes was the emergence of a new factor; the Party acting as an intermediary between the middle class and the proletariat. . . . The worker destroys in order to build–by knocking down a tree he makes his beam of wood. . . . Surrealism, lending its own method to bourgeois analysis, reverses the process; instead of destroying in order to construct, it constructs in order to destroy. . . . The *Wolf-table* of the latest Surrealist exhibition [Sartre refers to the Surrealist exhibition in 1947] is a syncretic attempt to encircle our flesh with a dark wooden feeling, and it is at the same time a reciprocal contestation of what is inert through what is living, and of what is alive through the inert . . . the object that is created and destroyed excites a tension in the mind of the spectator, and that tension is, strictly speaking, the Surrealist "moment"; the thing which is "given" is destroyed by internal contestation, but the very contestation and the destruction are contested in turn by the positive character and the "presence" of the creation. . . . For Surrealism, the whole man is the sum of all his activities. Faced with the absence of a synthetic formula, they prepared a play of opposites: this fluttering around of beings and non-beings should have been able to reveal subjectivity. . . . But their rejection of the subjective has transformed man into "a house where one feels". In the dark hall that is their idea of consciousness, there appear and disappear objects that destroy themselves, which are strictly similar to real things. Loud disembodied voices cry out, like the one which announced the death of Pan. . . .'

and Germany meet. Cologne especially is a meeting-ground of many tendencies: the spirit of the Mediterranean, French rationalism, the myths of Northern Europe, theosophy and Oriental mysticism, the German spirit and the civil conscience of the French Revolution are all mixed in a climate that is particularly stimulating for the questioning mind and for the debates of a very alert and up-to-date society. The natural scene, apart from the great plantations of fruit and asparagus, has two main features: the forest, which is symbolic of the Romantic *Sturm* and of Gothic cathedrals, of the whole irrational side of the German national character, as well as being the Freudian dream symbol for the cavern, the place of origin, and even the human soul itself, with its intrigues and dark recesses; secondly the river, the great green Rhine, whose appearance impregnates the whole of Ernst's work. In many of his paintings we may see greeny-blue shades, silent river backgrounds, fantastic creatures similar to the Oread nymphs, and aquatic vegetation, though only in 1953 did he dedicate a painting to the river alone. His father, Philipp Ernst, was a taciturn amateur painter and a teacher at a school for the deaf and dumb; he was a man who spoke little but whose gestures were full of meaning. He liked painting in the forest, inventing imaginary creatures and gloomy hermits, all with the lucidity and attention to detail characteristic of the amateur. Young Max used to join his father, around 1894, on these excursions into the forest, and it impressed itself on his mind.[21]

25 *La nymphe Echo*
1936
$18\frac{1}{8} \times 21\frac{5}{8}$ in (46×55 cm)
Museum of Modern Art, New York

Figs. 27, 11

Some of his most important works are on the theme of the forest: *L'Europe après la pluie,* 1940–42, *Vision inspired by the nocturnal appearance of the Porte Saint-Denis,* etc. His father's influence is also discernible elsewhere. When

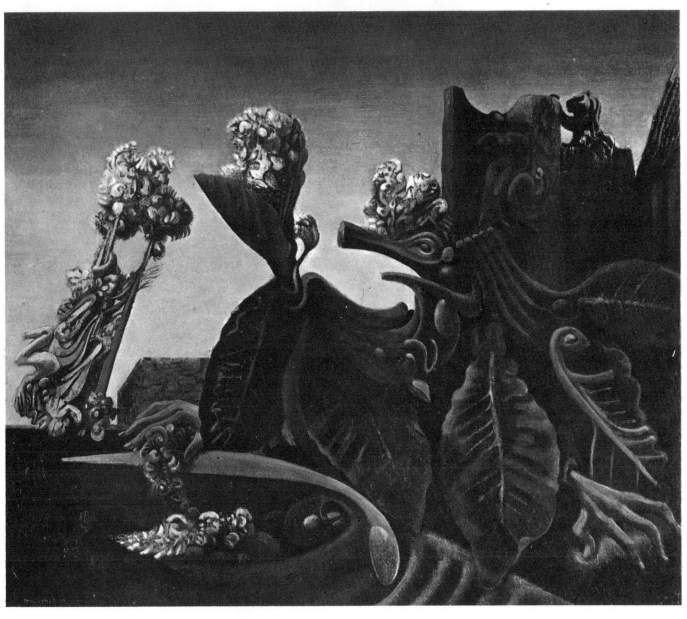

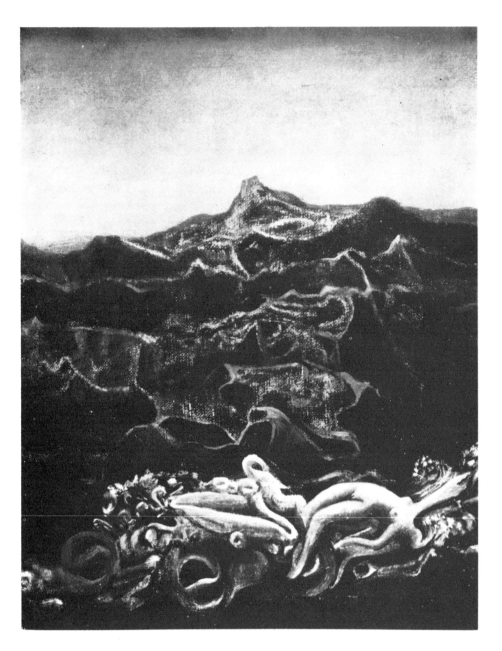

26 *La nymphe Echo d'Eluard*
1936, oil on canvas
$18\frac{1}{8} \times 21\frac{5}{8}$ in (46×55 cm)
Dorothea Tanning Collection,
Huismes

Max was five years old, he fled from home wearing a long nightshirt and carrying a whip and was recognized near a railway as the Christ child; his father then painted him as the Christ child.[22] Paintings such as *The Holy Virgin chastises the Christ child before three witnesses; A.B., P.E., and the painter* (1926) and *The chaste Joseph* (1927) are directly linked with this episode; the whip and the locomotive are very obviously symbols of sexual dynamism.

To these key features in the young Max's environment and that of his family, dominated by the figure of his father, to whom he even attributed responsibility for the death of his elder sister,[23] we should also add his exceptional imagination and capacity for concentration, amply recorded in the evidence of his 'diary'. In this he records his own visions, which were prompted simply by the 'shared' observation of inert and apparently

21 Surrealist thinking, which invited the artist to revisit the days of his childhood and relive its experiences, coincides perfectly with the idea of active memory that was always pursued by Ernst. In this connection, it is worth citing a passage from the well-known study by Theodor W. Adorno, *Reconsidering Surrealism* (1956): 'If one wants to explain Surrealism on its own terms, one should not resort to psychology but to its very artistic method, which is evidently that of montage'. It would be easy to show that Surrealist painting works around the theme of montage and that the discontinuous juxtaposition of images possesses the character of montage in Surrealist thinking. But those images derive, as is well known (partly from direct awareness and partly from an affinity of attitude), from the late 19th-century illustrations that were familiar to the parents of people such as Max Ernst. As early as the twenties, and outside Surrealist circles, there existed albums of such material (such as *Our Fathers* by Allan Bott), which exploited the Surrealist sense of shock, although they saved themselves the trouble of achieving the effect of estrangement through montage. The true Surrealist overlaid the unusual character of those illustrations with other unusual effects: it is the latter which endow the former with their striking force – that familiar note which prompts the query 'Where have

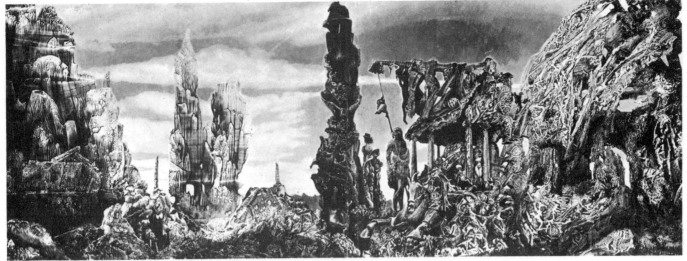

27 *L'Europe après la pluie*
1940–42
Wadsworth Athenaeum, Hartford

28 *Jeune homme intrigué par le vol
d'une mouche non euclidienne*
1942–47
oil and lacquer on canvas
$32\frac{3}{8} \times 26$ in (82×66 cm)
Private Collection, Zurich

I seen that before?' The affinity with psychoanalysis should therefore be seen not only in the symbolism of the unconscious, but also in the attempt which is made to lay bare, through some veritably explosive effects, our childhood experiences. What Surrealism adds to the images from reality is that which we have lost since childhood: when we were children those illustrated periodicals must have had the same impact as the Surrealist ones do today. The subjective element lies in the adoption of montage, which is intended to provoke in an extremely clear manner – even if it is in vain – perceptions similar to those we had then. The colossal egg out of which a monstrous Last Judgement may spring at any moment is as gigantic as it appears because we were so small and trembled the first time we saw an egg. . . .'

22 Cf. the autobiography, p. 92.
23 Ernst does not seem to have had any special memories of his mother, apart from the numerous pregnancies which drove him to ask himself how his father behaved on the night when he was conceived.

inexpressive figures and matter–crumbling plaster, scrubbed floorboards, wallpapers, etc. There were two important events during his early adolescence: the birth of his sister Loni and the death of his pink cockatoo in 1906–two events which Max linked in his mind, to the extent of deciding that the birth of the young child had provoked the death of the bird. This led him to become absorbed in occultism and magic, a fact recorded in a manuscript of his, the *Diver's Manual,* which is strongly influenced by the anarchist ideas of Max Stirner.

It has been thought necessary to establish some of the key points of the framework on which Max Ernst's artistic development is built in order not only to provide an interpretative key to his work, but also to re-emphasise the fact that his participation in the Surrealist movement was founded on an essentially independent vision of the world (even though he came close to Surrealist ideas). It must be stressed that it is hopelessly inadequate to seek to explain his work on the basis simply of Dada and Surrealism.[24]

The works of the first decade of his activity, from 1909 to 1918, are clearly linked with Ernst's childhood both on a psychological level and so far as their setting is concerned. But to give an idea of their pictorial qualities and the techniques with which they are painted, it should be said that unlike the works of his maturity, which are seen through the filter of the memory, these paintings relive the immediacy of the sensations which they attempt to portray. In this way the *Paysage et soleil* (1909), although anticipating some of the themes and features which are to recur emblematically in later work, has a Fauvist handling of Expressionist origin. The brushwork, with its tight curves (very different from the absolute technical mastery which

Fig. 2

24 On this point, see G. C. Argan, *Max Ernst e la 'Gaia Scienza'* in *La Fiera Letteraria,* Rome, 30th June 1966.

30 *Vox Angelica*
1943, oil on canvas,
30×40 in (76×101·5 cm)
Julien Levy Collection,
Bridgewater

characterises later work), and the force of the colouring, based on pure colours (with combinations achieved almost by accident on the canvas itself), and the composition itself, frontal and devoid of perspective devices, have an immediacy that is worthy of Van Gogh, Ensor or Nolde. At this time Ernst took part in the activities of the 'Young Rhineland' group, which was inspired by the revolutionary ideology of Expressionism. *Der Sturm* (1912) continues the same figurative characteristics, although the image emerges with greater clarity from the matter of the background. The subject is that of the storm in the forest, and the style recalls that of the 'Brücke'[25] painters as well as Albrecht Altdorfer. But the Expressionist tendency was short-lived. In 1916, Ernst, who had already been to Paris and had met Arp in Cologne in 1914, began seeking a more complete figurative vocabulary through a technique that was easier to handle, and a new compositional stress that placed more importance on mental balance than on naturalistic semblance. His *Vegetation* of 1916 represents a forest which has already begun to take on the dimension of memory. The interpretation furnished by the mind and logic translates the image into a construction of it which might recall a Cubist or Futurist landscape (although there is no question of direct imitation); this is a characteristic also of a number of other works of the same period. The *Combat de poissons* (1917) employs the same context for an experiment in colour-distribution on Cubist lines; the figuration also is Cubist in derivation, while the author is simultaneously involved (as a spectator within the work itself) on Futurist lines. There is also a development of the image in a dream state; following the absurd juxtaposing logic of the dream-world, moments of rationality are combined with unconscious elements.

Fig. 3

25 The works of artists belonging to this movement were exhibited in Dresden in 1910.

In 1919, Max Ernst experimented almost systematically with Dada techniques. Nevertheless there are other works from the same year which show a definite desire to recreate a dreamlike 'surreality' (*Untitled*) and metaphysical images derived from De Chirico's perspective views (*Aquis submersus*). The work of the latter artist had a great deal of influence on Ernst, especially as regards his combination of objects that have no relation to each other, and his creation of a new spatial dimension which depended on an inconsistent and arbitrary use of Renaissance perspective.[26]

After the Dadaist interval, Max Ernst's work no longer follows a pattern of derivation and organic development. He dedicated himself to continual experiment in technique and imagery, abandoning himself wholly (though calculatedly) to the relentless flow not so much of painting as a study, but of poetry as a way of life. The image is never dissociated from the technique, but rather is tied to and controlled by it, to the extent that a new technique

31 *Euclid*
1943
D & J de Menil Collection, Houston

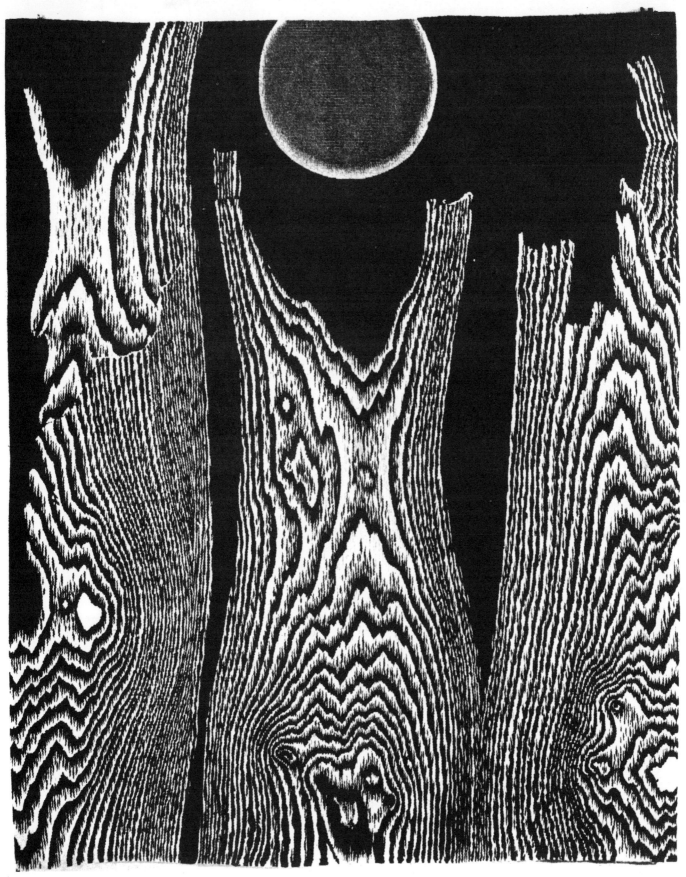

gives rise to a new image and vice versa, while the imagination follows its own unpredictable track.[27]

Following the fluid progress of the imagination through the random wanderings of dreams is like tracing the tortuous paths of an immense labyrinth in a state of lucid delirium. Since there is no thread to follow except that provided by the imagination and the dream—by nature changeable ephemeral and illogical—it is easy to understand how the image often

32 *Forest*
1956, tapestry printed from a lithograph
$48\frac{1}{2} \times 38\frac{1}{2}$ in (123 × 98 cm)
Katy Sursok Collection, Genf

26 Max Ernst had 'discovered' De Chirico in Munich when he bought a copy of the review *Valori Plastici,* in which the artist's most recent research had been published.
27 Cf. G. C. Argan, *op. cit.*

33 *L'oiseau rose*
1956, oil on canvas
18⅛ × 24 in (46 × 61 cm)
Twentieth Century Gallery, Berlin

returns to its earlier forms, even when these occurred at a distance in time of many years.

The myths of his own time

In 1918, Ernst set about 'finding the myths of his own time'. Hand in hand with this purpose went his participation in Dada, beginning in 1919, the year in which he chose the pseudonym 'Dadamax'. He arrived at this through the elision of 'dadafex maximus', a play on words with an obvious ambiguity and dual meaning. The techniques which he used up to 1921 were largely those of *collage* and *montage*; in both pictorial and graphic work his fertile imagination was prompted by inspiration from the fields of literature, music, the theatre, choreography, philosophy and criticism. He met Apollinaire, read Nietzsche and Stirner. He produced a novel made up Fig. 16 entirely of collages, *La femme 100 têtes,* employing older prints whose style is dominated by the most rigid and conventional 19th-century realism, in open contrast with the alterations to the images that Ernst makes. A number Fig. 6 of major paintings date from the same period: *The Elephant of the Celebes* (1921), which combines a spatial sense reminiscent of De Chirico with imaginative elements of a very varied order (later to be adopted by Dali, Figs. 7, 5 Tanguy and Magritte); *Oedipus Rex* (1921); *Two ambiguous figures* (1919–20), which includes an unusual combination of a geometrical and abstract spatial environment with metaphysical connotations and a typically dream-like selection of scientific and imaginary forms. But the works which are most characteristic of this period show the Dada taste for experimentation in many materials and hostility towards imagery, and reach a peak in works Fig. 4 Pl. 5 such as *Fruit d'une longue experience* (1919) and *Katharina ondulata* (1920). In these works, Ernst manipulates the elements and endows them with new meaning, placing them in a sort of limbo half-way between the worlds of reality and the dream. Ernst's achievement lies in having created an environment in which the object seems to exist as if for the first time: the author himself contributes to the birth within an all-embracing dimension that is not that of the choice of object (as in Dada *assemblage,* where the artistic property – if one can talk in such terms – lies in the artist's choice of dissimilar or discarded objects) and instead is, as G. C. Argan has said, 'the definition of a third level, that of reality made present and visible by the image or by the object that is real-to-the-imagination'.[28]

Ernst fills the image with allusions and references. His reality is one which

28 Cf. G. C. Argan, *op. cit.*

has many levels and facets. The very nature of the work is put into question: just as in the dream there is no boundary between reality and fiction, so the two concepts overlap and the more the fiction is self-sufficient, the more it resembles reality and becomes an objective experience.

Objects given another name (reflecting a Dada tendency) are examples of a doubling of the meaning of the experience. This is not so much—as it was for Dada—a desire to invent another name for an object in order to turn it into something brand new, but rather the adding of a second meaning to the old one, thereby leaving some doubt as to which is the more 'exact'. This is basically the same doubt as Nietzsche evinces before 'reality'. The irony Ernst achieves is based on the ambiguity and uncertainty as to what part reality plays in his work, whether it has a participant's or merely an observer's role in this turmoil of unfamiliar sights.

34 *Le grand Albert*
1957
$59\frac{7}{8} \times 41\frac{3}{4}$ in (152×106 cm)
D & J de Menil Collection,
Houston

35 *Pour les amis d'Alice*
1957, oil on canvas
$45\frac{1}{4} \times 35\frac{1}{2}$ in (115×90 cm)
Anne Doll Collection, Paris

Frottage 1925 marks the official birthdate of *frottage* (although its development was anticipated by some experiments in 1921). This was to become Ernst's best known technique, and the artist himself described its origins.[29] This discovery came about as the result of a search for media which would make the image conditional on technique. Even where everything is imaginary, the technique is nowhere separated from the artistic purpose, but rather the latter is achieved through and in it, in a process of continual osmosis. This is the background to the *Histoire Naturelle,* which is almost a re-reading of the history of the world, a new genesis. Form is created spontaneously, by inference. In this context it is usual to speak with greater emphasis of the 'automatism' of Ernst's creative processes; it is just as if the creation of the image depended on the operation of a mechanism which begins functioning as soon as the impediments of logic, commonsense and alertness are quieted. This current interpretation should be corrected: 'Ernst does not narrate dreams, he creates them' (G. C. Argan).

This means that, unlike the Surrealists, he is not involved in the 'automatic' operation; he remains outside it, in clear consciousness, ready to contemplate his own dream.

As has been noted above, it is no hypnotic trance or hallucination that gives rise to the image, but an internal force within the representation itself which endows it with the fascinating ability to recreate itself. This technique

29 Cf. the autobiography, p. 94.

40

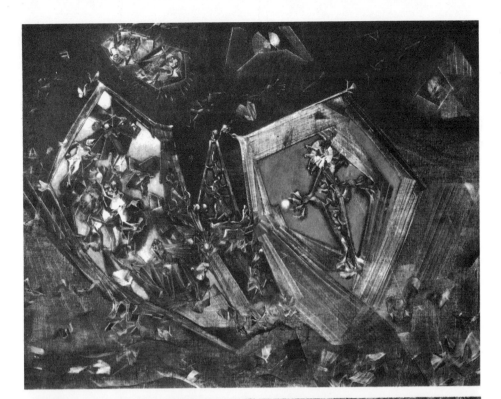

36 *Mundus est fabula*
1959, oil on canvas
51½ × 63¾ in (131 × 162 cm)
Museum of Modern Art, New York

37 *Quasi-feu le romantisme*
1960, oil on canvas
13 × 9⅜ in (33 × 24 cm)
P. Marinotti Collection, Milan

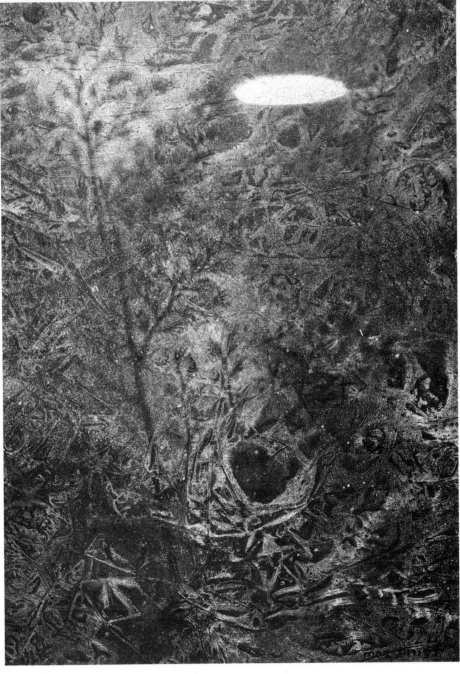

does not lower the critical and creative capacities of the artist, but rather gives them strength and imaginative fertility.

Ernst used frottage on a variety of materials, most frequently wood, but also plaster, leaves, stones, the thread of the canvas, the milling on coins, the relief of shells. When Paul Eluard first saw the *Histoire Naturelle* series, he asked himself 'Is it that the mirror has lost its illusions or that the world has lost its opacity?' The remark illustrates the true character of the method; reality is laid bare, and there is no difference between the image of reality and the reality of the image. The underlying meaning of things is tapped, there are allusions, ambiguities, a feeling of adventure, and one turns especially to self-examination. There is also a deep feeling for geology, a natural exploration which comes out in the various earth forms that make up the prehistoric landscape. Ernst's concern for natural history during his career takes him backwards in time; from the intermediary stage of water (whence all organic life) he moves in his late maturity to the theme of the white-hot magma as the primary constituent element of the world.

The technique of *frottage*, whether used on its own or combined with traditional techniques, characterises Ernst's major works: *The hunter* (1926) is an imposing assembly of anthropomorphic, animal, vegetable, architectural, technological and earth forms, bound together by the uniform blue sky, painted with a sort of fairground simplicity.[30] *Paysage-coquillages* (1927–28) has a more abstract character, but with suspended meanings and forms that are the more disturbing for that abstract character so different from that of the Ecole de Paris. *Le rendez-vous des amis—les amis se changent en fleurs* (1928) is a mixing pot that differs from Jackson Pollock's most advanced 'dripping' paintings only in the marked contrast between the image and the background. The theme of the 'horde' is specifically characteristic of the whole of 1927, but it also reappears later. This subject, because of the doubling of the meaning,[31] can have different titles without having an essentially different figurative content or appearance, and it can be interpreted in several different ways. It can be read as a symbol of the irrationality of the barbarian marching from the East to the West to overthrow the rational structure of Western society, following Artaud's concept; a deeper probing could see it as a return to the obsessive and threatening memory of the forests of Ernst's infancy (life before birth, and the safety of his mother's lap), as the memories of a vegetable world ready to undergo hallucinating transformations in the direction of the animal world in the constant creation of omniverous monsters thought up by an imagination whose mental balance is on edge; it can also be seen as a sign of angry hostility against the modern world which the artist transforms, perhaps in retaliation, into images that are totally anti-technological, formless like the human beings of our day that are ready to become a shapeless mass, a multitude without individual characters.

The technique of the 'hordes' is primarily that of *frottage*. But in the same years Max Ernst was also experimenting with another method—he called it *grattage*—which involved scraping the colours on the canvas with a spatula. This resulted in a certain ambiguity and confusion of colours, with spotted areas and indistinct outlines, and these characteristics can also be seen in some of the series of 'hordes'. Typical products of the *grattage* technique include *Forest and earthquake* (1926), *Bird marriage* (1927), *Two girls and a monkey with palettes* (1927), *Man, a girl's best friend* (1928) and some others.

These methods of rendering the artistic process more objective made Ernst fascinated with anything that was automatic, that was not governed by the artist's intentions and in which the artist played only a guiding or finishing role. Extending this principle, Ernst made his own drawing objective; in an attempt to free his hand from the instinctive impulse to

Pl. 16

Fig. 15

Pls. 22–23

30 Appreciation of the coarse features of inn-signs came from as early as Rimbaud.
31 Illustrative in this context are the titles of works like *Femmes traversant une rivière en criant* (1927), *Barbarians marching Westwards* (1933), *Vision provoquée par les mots: 'Le père immobile'* (1927), *Famille* (1927), *La horde* (1927).

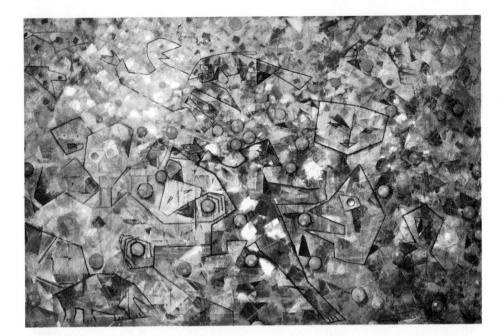

38 *Un tissu de mensonges*
1959, oil on canvas
$78\frac{3}{4} \times 118$ in (200 × 300 cm)
Author's Collection

39 *Fête à Seillans*
1964, oil on canvas
$55\frac{1}{8} \times 78\frac{3}{4}$ in (140 × 200 cm)
Author's Collection

draw a photographic image he would dip a long string into the paint and then place it on the canvas, allowing its movements and crossings to suggest the best way of developing the composition. Many important works originated in this way, including *The bride of the wind* (1926), *The kiss* (1927), *Several persons, one without a head* (1927) and *A night of love* (1927).

Fig. 12

The fascinating sinuosity of this line, its energy vitalised and regenerated in a way that recalls the Baroque, is also the basis of the series of 'birds'—another cardinal theme in Ernst's work. Birds have for the artist a precise symbolic meaning: that of the winged creature that flies free, like the imagination, above the earthly horrors of the hordes; a being that remains pure and uncontaminated in spite of the moral and physical corruption of minds and bodies; it represents man's insuppressible aspiration upwards, to the supernatural and the metaphysical. When Ernst gained this conviction and identified the direction of his activity and the focus of his imagination in the appearance of a bird, 'he decided to erect a monument to birds'. This was the origin of the famous series of 'monuments to birds' (1927), a collection of sinuous forms that float in a vacuum, free from all earthly burdens and even gravity, and depicted in a symbolical language that recalls the Christian

Bird superior

iconography of the Resurrection. This recurs in another important work in 1927, *Après nous la maternité*, as a parallel to which Russell cites Raphael's Madonnas.[32]

Ernst's self-identification as a winged creature was consummated in 1928 with the creation of Loplop–Bird Superior, to whose description the artist devoted considerable space in his autobiographical notes and poems. Apart from this, the symbolism of birds takes up a large proportion of Ernst's work before 1931. It is not always the central motif; often it makes an un-

Fig. 11
Pl. 17

expected appearance, as among the rocks of a petrified forest (*Vision provoquée par l'aspect nocturne de la Porte Saint-Denis*, 1927; *The grey forest*, 1927; *Oiseau au cœur de la forêt*, 1928), or as an almost heralidic motif

Fig. 17

(*Intérieur de la vue–L'œuf*, 1929), or else it assumes the form of a genuine emblem (*A l'intérieur de la vue–Les oiseaux*, 1927; *L'élue du mal*, 1928; *L'homme et l'oiseau*, 1930).

Meanwhile, Loplop continues her appearances, renewing and reassessing a whole vocabulary of Dada ingredients, whose inclusion is achieved by Ernst with the confidence of one who is not bound by temporary fashions and also especially of one whose working method enables him to start entirely afresh before each work. This is borne out in examples such as

Pl. 24
Fig. 20

Loplop présente . . . and *Loplop présente une jeune fille*, both of 1930, and also *Loplop présente une fleur* (1931), whose forms are abstract although a meta-physical sense of space and specifically Surrealist features, such as the blossom with stuffed birds, rendered realistically, intrude.

Mundus est fabula

Ernst extends his vision of the world–the external reality begins to coincide with an internal one. He writes: 'The painter should close his eyes in order to see the image with his spiritual vision'. This vision turns out to be almost prophetic–Ernst begins to have premonitions of an impending catastrophe. He begins meditating on the theme of Europe and her destiny; the enchanted

Pls. 29–31

fantasies of the *Jardin gobe-avions* with their fascinating and repugnant feather-flowers are interspersed with monsters of a threatening aspect

Fig. 24

(*Confidences*, 1935; *Triomphe de l'amour*, 1937) and Athenian or Baby-lonian landscapes that are irremediably petrified, ruins in the midst of inert

Pls. 32–33

vegetation (*La ville entière*, 1936), which recall, as Russell suggested, Montecassino after its destruction.

Ernst's painting begins to provoke a new emotion–that of revulsion. The technique he adopts reflects this state of mind–the forms appear slimy, slobbering and repellent in consistency, forestalling Dubuffet by twenty

Fig. 25
Fig. 26

years (*Aux antipodes du paysage*, 1936; *La Nymphe Echo*, 1936; *La Nymphe Echo d'Eluard*, 1937; *La Nature à l'aurore*, 1936; *L'auge du foyer*, 1937; *Chante de soir*, 1938; *Epiphanie*, 1940). The nature we see here is ghost-like, the vegetation that of a greenhouse or tropical hothouse, suspended in a motion-less calm as if waiting for the advent of some cataclysm that will burn the plants, reduce the air to atoms and produce unnatural metamorphoses. In these canvases Ernst developed a new technique – some areas of the canvas are rendered with an attention to detail worthy of an Arcimboldo, while others are made up of layers of colour forming strange patterns, achieved through the application of very diluted colour onto the canvas with a flat instrument. This is the technique of *decalcomania*, which had already been practised by Oscar Dominguez in 1937. This technical innovation facilitates the sugges-tion of the ruined, the fossilised and the lifeless; surfaces seem to be decayed, eaten away by acid and pierced by innumerable holes like the surface of a sponge. When the premonition of war was translated into reality, Max Ernst fled to America. But the memory of a Europe torn asunder pursued him: in his place of refuge at Santa Monica he painted works that are full of a despairing melancholy, such as *Le miroir volé*, *The harmonious breakfast* and *Napoleon in the desert*, all of 1941. He also finished the monumental

Fig. 27

composition of *L'Europe après la pluie II* (1940–42)–a funereal scene full of

32 Cf. John Russell, *op. cit.*

40 *Laïcité*
1965, oil and collage on wood
$45\frac{3}{4} \times 39\frac{3}{8}$ in (116×100 cm)
Alexander Jolas Gallery, New York

waste and putrefaction, peopled only by bestial creatures that wander around in solitude.

But Ernst's creativity is too cold and detached (although he possesses the facility for controlled, indeed emphatic, emotion) to permit this devotion to the *lacrimae rerum* to dominate his work. 1942 saw impressive experiments with 'dripping'. He allowed the colour to drip from holes in a can which he swung with a regular motion above the canvas. He used this technique in *Young man intrigued by the flight of a non-Euclidean fly* and *The confused planet*.

In 1943, his move to Arizona occasioned a reconciliation with landscape: here in reality was a natural landscape such as he had often created in his imagination in previous years. There was opportunity for recollections: 1943 brought the disconcerting polyptych *Vox Angelica,* which is a visual and somewhat sentimental recapitulation of the most important stages in his cultural development. The various geometrically arranged sections show the submerged world of *decalcomania,* geometrical *frottage* forms, historical monsters and psychoanalytical symbols, geometrical abbreviations rendering the sea, the simulated wood of the *grattage,* the birds and the sky, the anthropomorphic geometrical and mathematical instruments (which in the lower compartment on the right compose the letters MAX) and finally the Eiffel Tower and the Empire State Building, the symbols of the two most important cultural presuppositions for his work. Other important works of this period include *La nuit rhénane* (1944), *L'œil du silence* (1943–44), *Everyone here speaks Latin* (1944) and *The Temptation of St Anthony* (1945). The techniques in which these works are executed are those already tried in previous years, but the handling is much more refined and is carried to a far greater degree of technical craftsmanship, seeming to be inspired by the 19th-century 'visionary' artists – most especially Arnold Böcklin and Gustave Moreau.

Fig. 30

Fig. 29

The works of these years show a deliberately conceived peak of technical excellence, which is abandoned in works after 1945, where Ernst is concerned with new spatial effects and forms of a different evocativeness, as in *Bird, sun and sea* (1947), *Les phases de la nuit* (1946), *Deux vierges folles* (1947), *The cocktail drinker* (1945), *Euclid* (1945) and *La naissance de la comédie* (1947).

The American period comes to an end with the tiny miniatures of the *Seven Microbes* series, which constitutes a tribute to nature in Arizona – its sand, stones and colours that are so different from those of Europe.

In 1949, Max Ernst went to Amsterdam, Brussels and Paris. He worked on the possibilities of light, the tradition that runs from Rembrandt to Géricault, but with more accent on the blinding light of the sun: *Father Rhine, The raft of the Medusa* (1953), *L'oiseau rose* (1956). At the same time he exploited the techniques which he had developed throughout his career: *frottage, grattage* and *decalcomania*. The images become more fluid and lose their sharp outlines. However, some images – the bird, the sea, the sky – remain unchanged. The image is broken up into many facets like a quartz crystal; this is not a return to Cubist imagery (although it is similar in appearance) but yet another extension to the dimension of the visionary. Nor is fantasy lacking, as we find in works such as *Pour les amis d'Alice* (1957), *Les dieux obscurs* (1957) and *Mundus est fabula* (1959).

The colours become continually more tenuous, and it is the light itself which appears to be materialised in a thousand impalpable evanescences. The *decalcomania* produces a few elements of Art Nouveau character in a disturbing, Ossianic night, as in *Quasi-feu le romantisme* (1960). The same spirit also characterises the lyrical and coldly erotic *Portrait of Dorothea* (1960), which was anticipated by the painting Ernst created in 1958 after the death of Paul Eluard: *La tombe du poète – Après moi le sommeil*.

In the fifties, the upheaval of Abstract art left little trace on Ernst's work. Nevertheless, some works painted after 1960 show traces of the most important developments in modern painting. While *Le mariage du ciel et de la terre* (1962) continues the theme of light in a coherent fashion, it also possesses a colour scale and spatial rhythm akin to Rothko; while *Question d'insecte* (1963) suggests a parallel with Bacon and *La fête à Seillans* (1964), one with Dubuffet. There are a few abstract references in other works and many of them are purely incidental. They were obviously possible only where they coincided with Ernst's own need to invent, recreate and 'begin anew' in the basic dimension of the spirit. It is certainly no accident that some of his most important recent works, such as *Le Grand ignorant* (1965), *Laïcité* (1965) and *Le printemps rédempteur et rédimé* (1965), go 'beyond painting'. In some ways they recall the 1920s, 'beginning anew' with the Dada of forty years earlier.

Fig. 31

Pl. 38 Figs. 35, 36
Fig. 38

Pl. 39

Fig. 39

Pl. 40 Fig. 40

2 holoëder sulfate silicate picastrate u. zwillinge nach meiner wahl mit stäbche

max ernst

POINTS

SPACE

ADE MA

EARL OF TROY

3 PLY BAND

b.a.t. Max Ernst

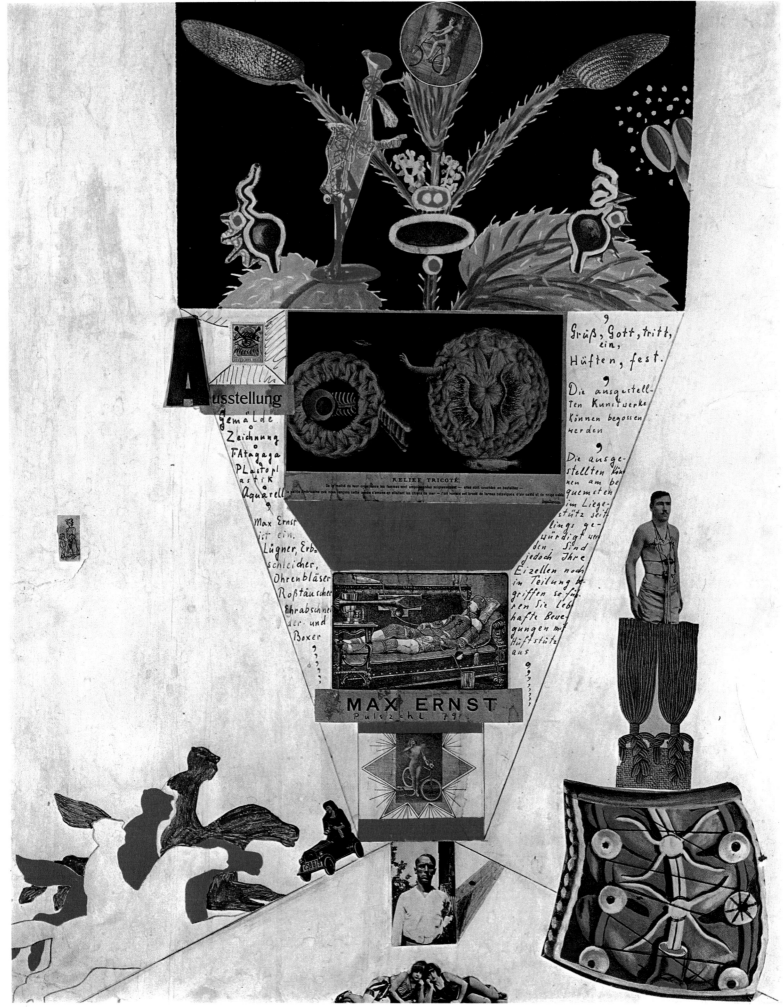

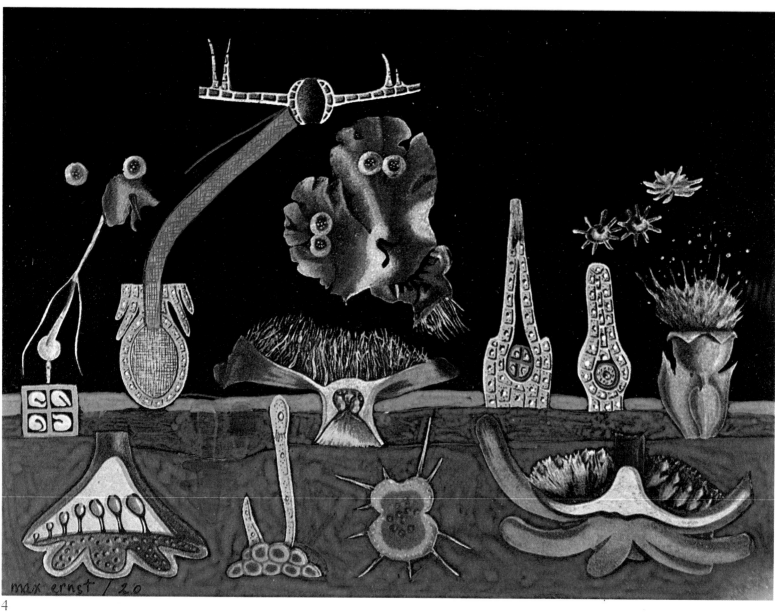

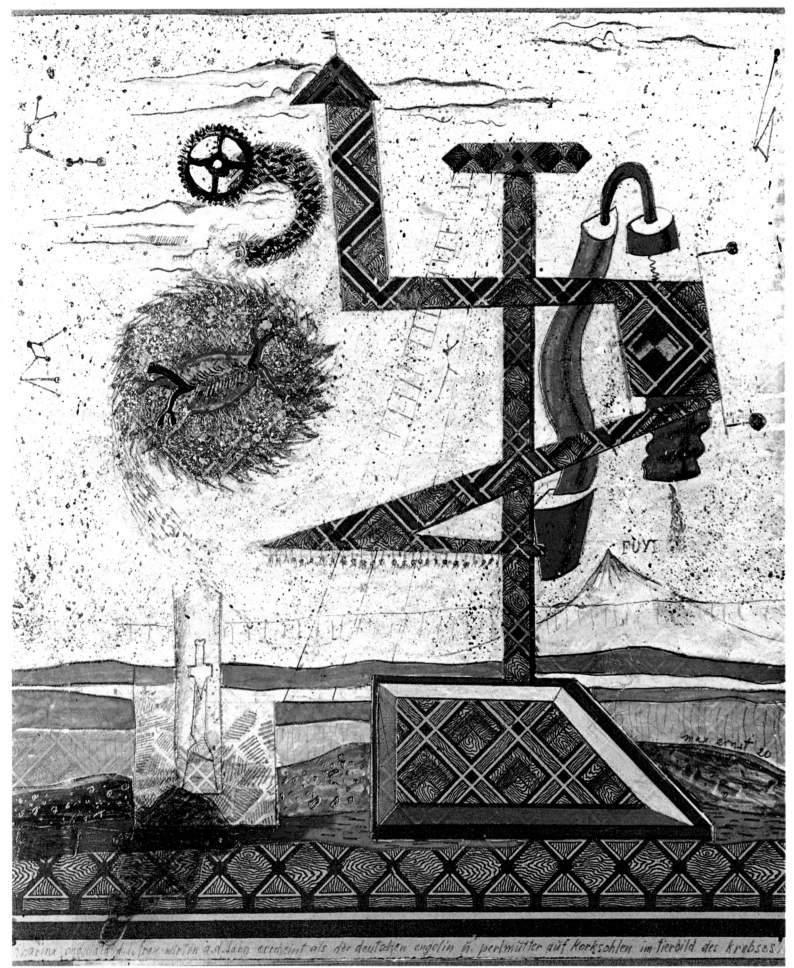

katharina ampadais d... frei wirtin a.d. lahn erscheint als der deutschen engelin ü. perlmutter auf korksohlen im tierbild des krebses!

le chien qui chie le chien bien coiffé malgré les difficultés du terrain causées par

une neige abondante la femme à belle gorge la chanson de la chair / max ernst

6

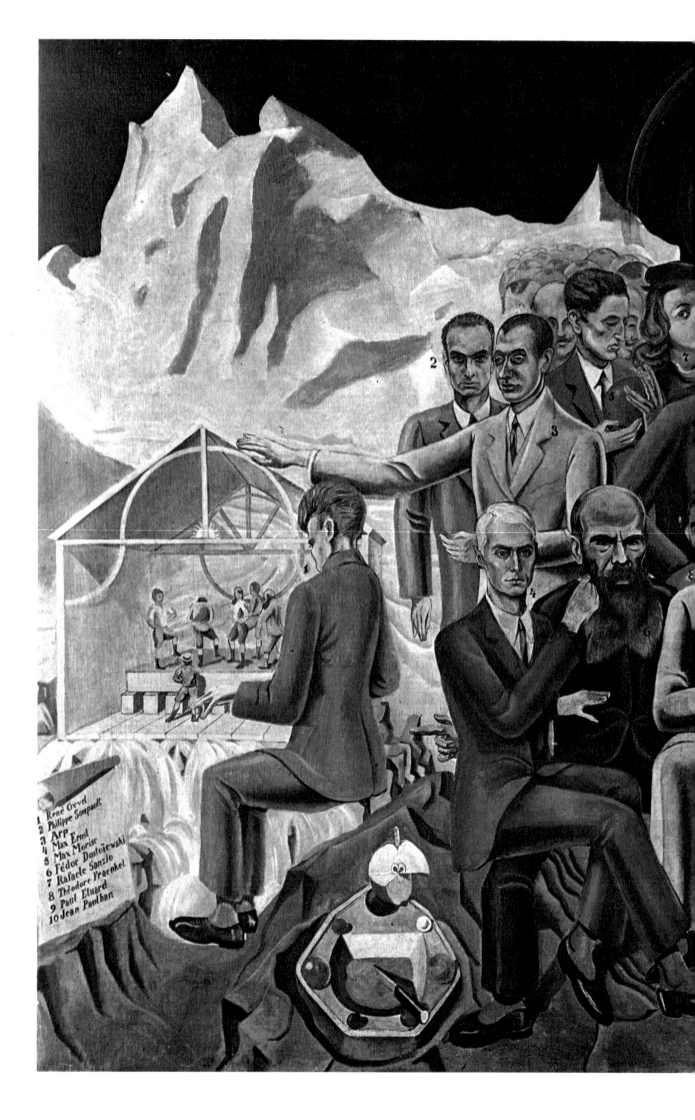

1 René Crevel
2 Philippe Soupault
3 Arp
4 Max Ernst
5 Max Morise
6 Fédor Dostoiewski
7 Rafaele Sanzio
8 Théodore Fraenkel
9 Paul Eluard
10 Jean Paulhan

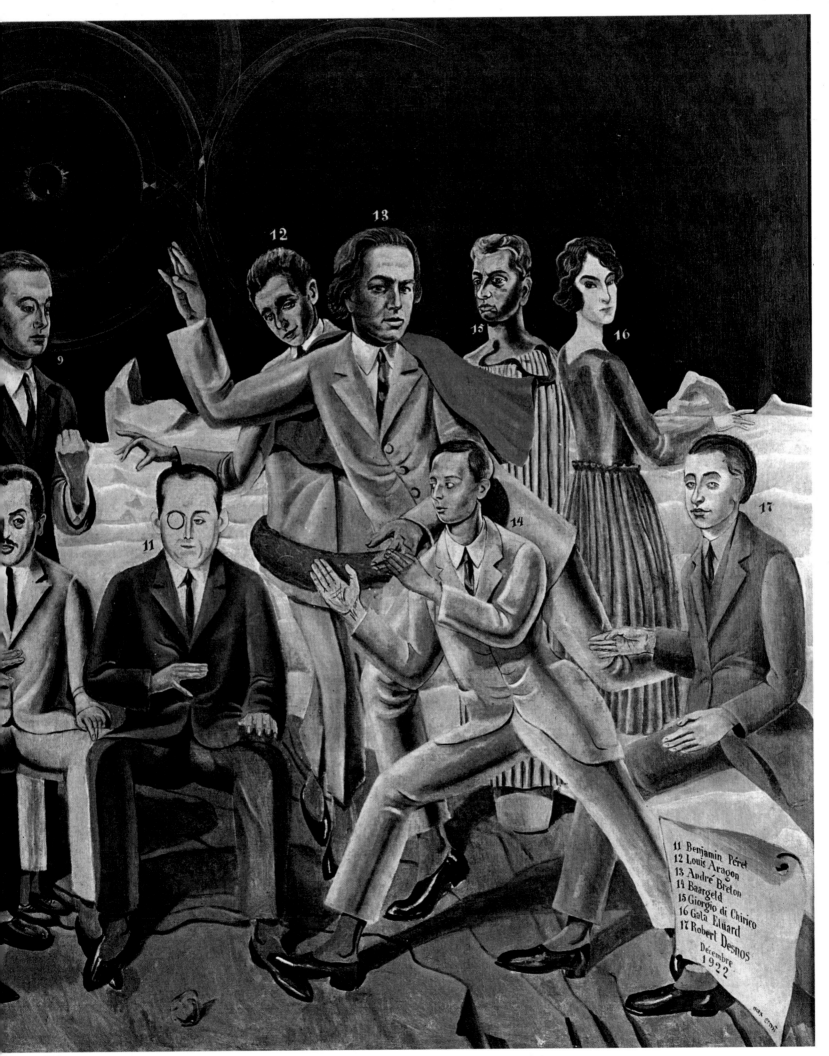

11 Benjamin Péret
12 Louis Aragon
13 André Breton
14 Baargeld
15 Giorgio di Chirico
16 Gala Eluard
17 Robert Desnos
Décembre
1922

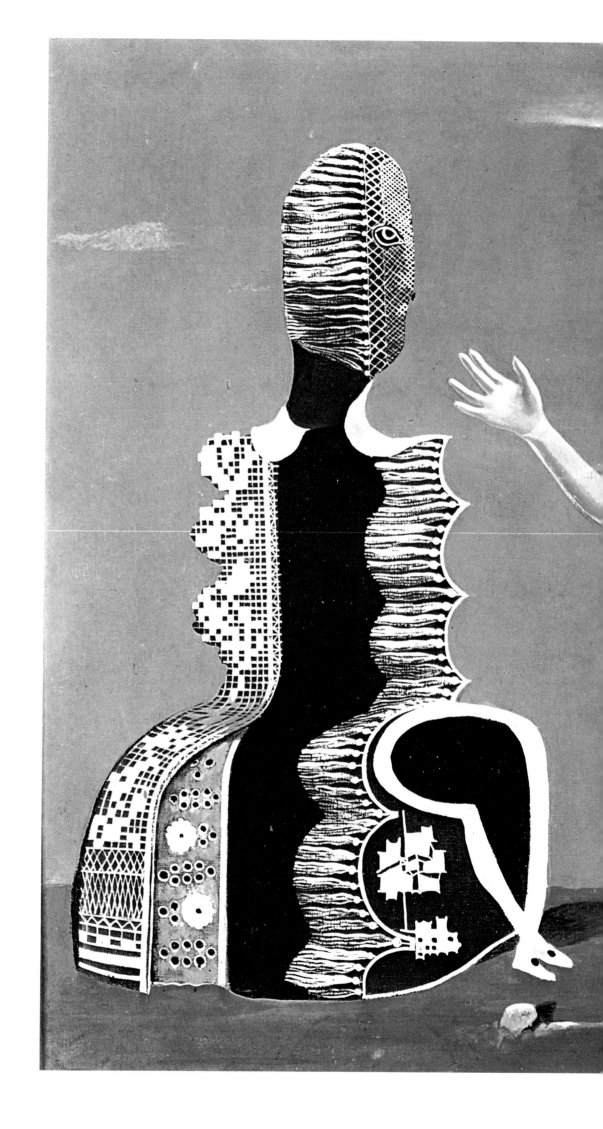

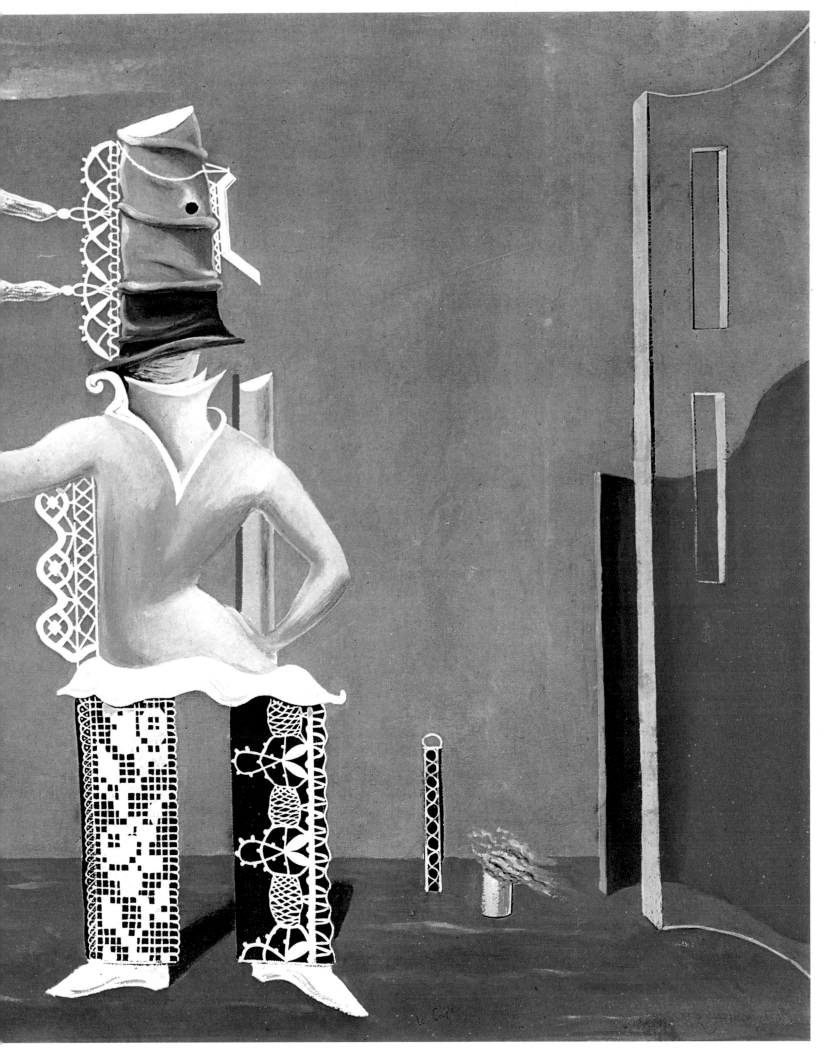

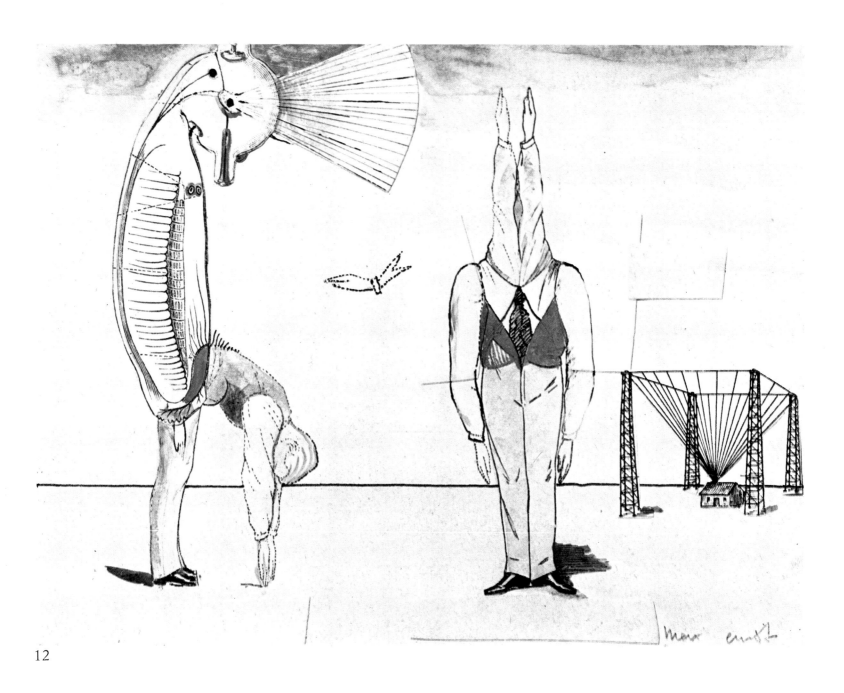

12

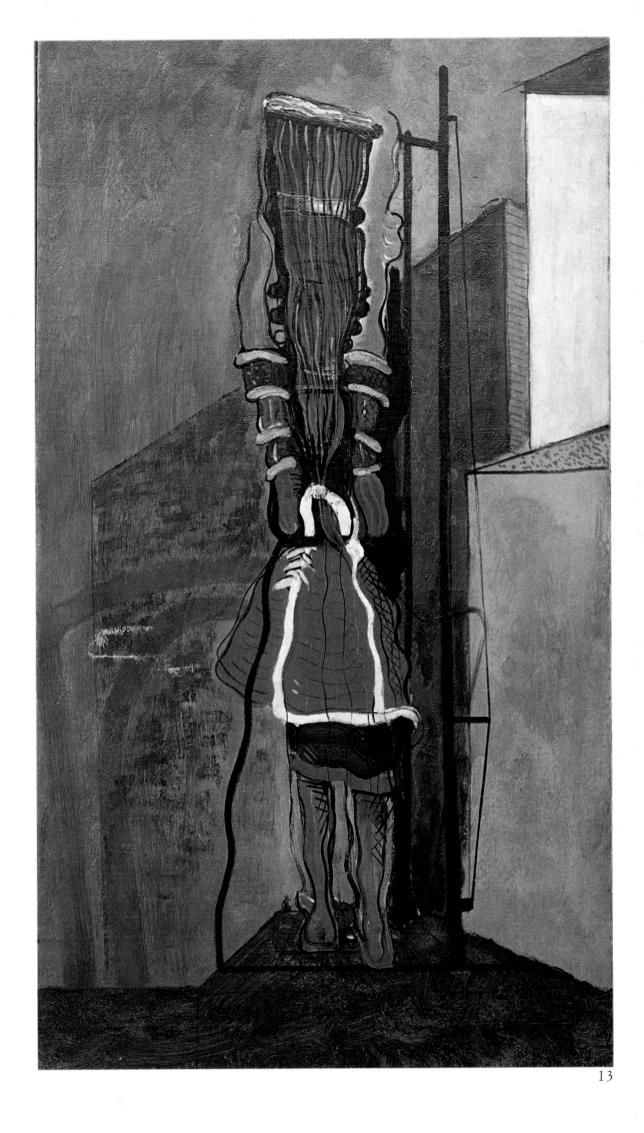

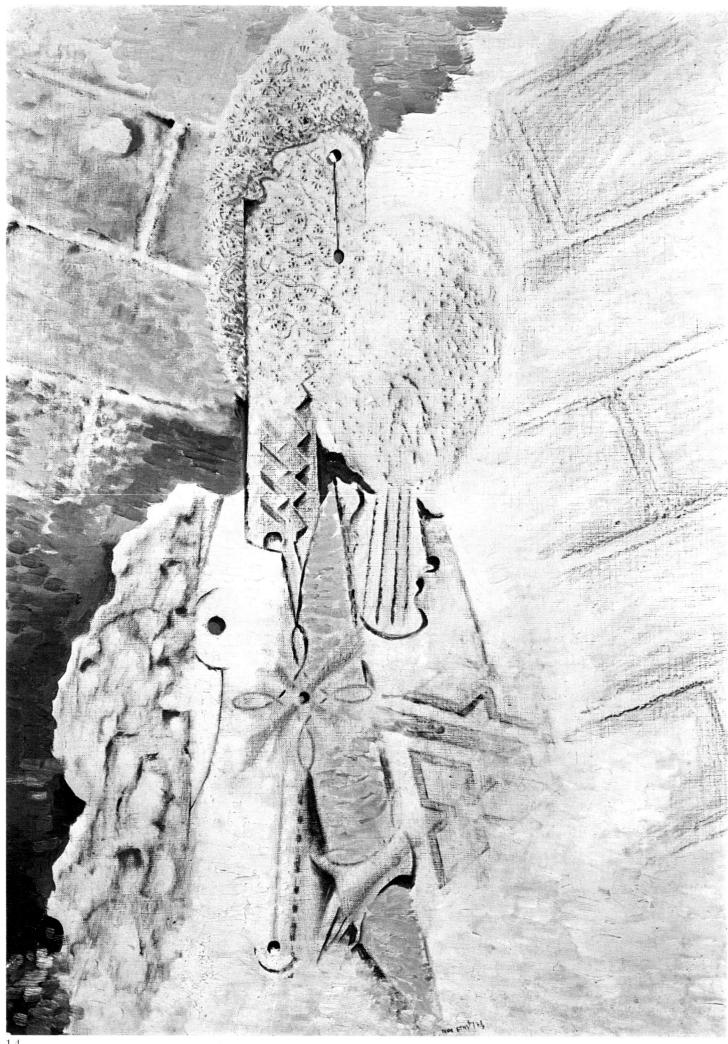

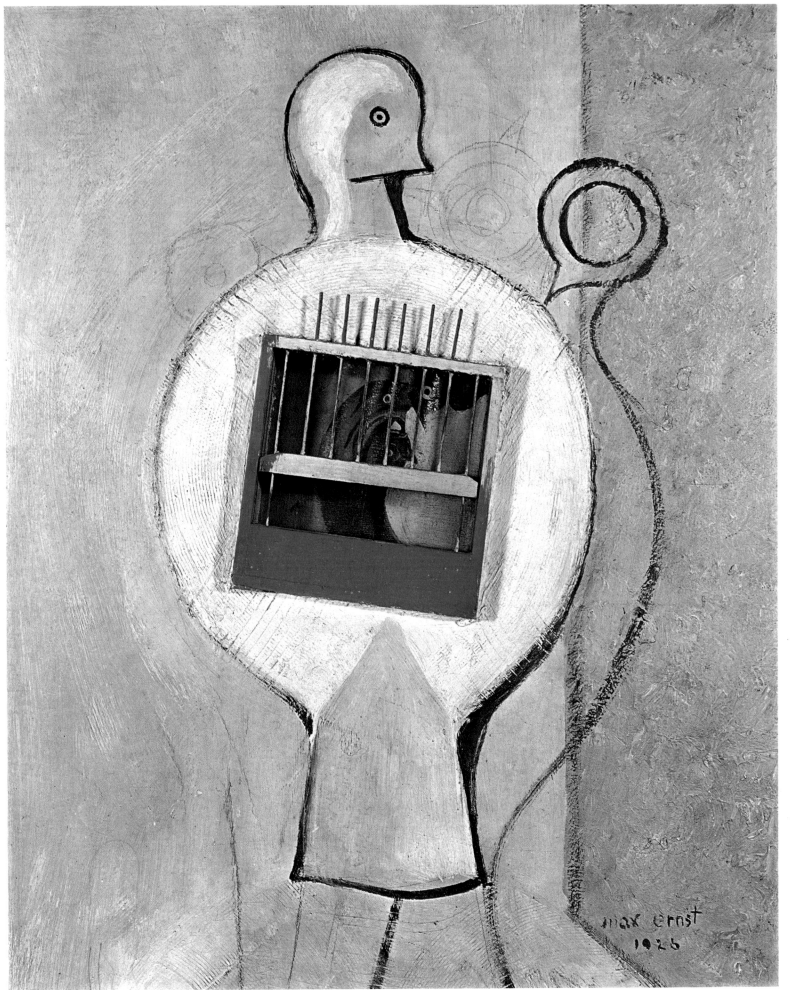

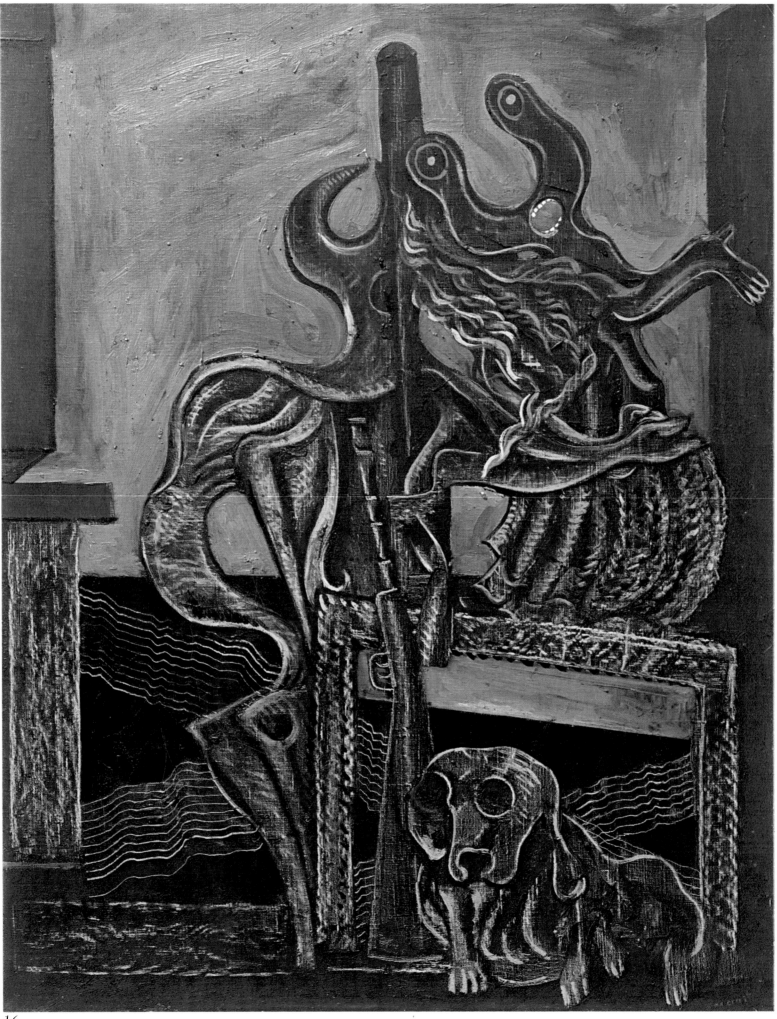

16

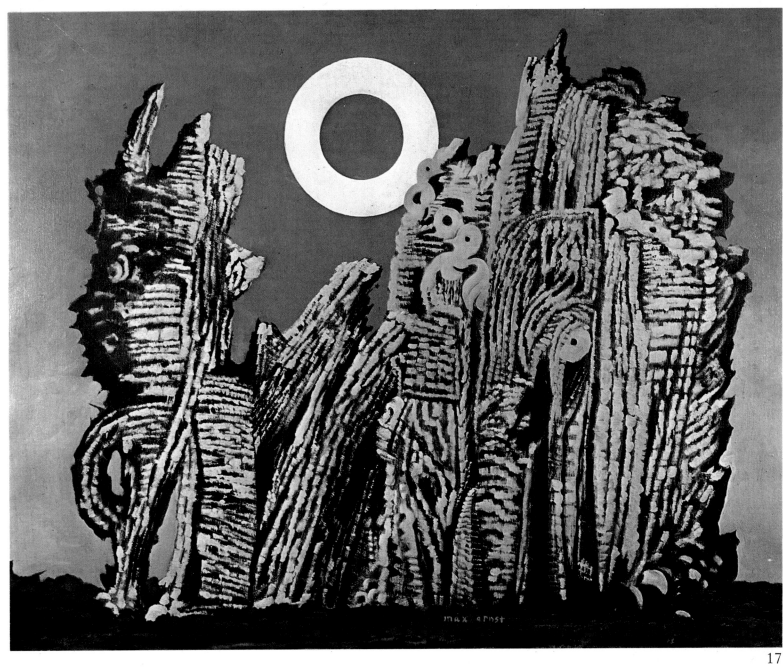

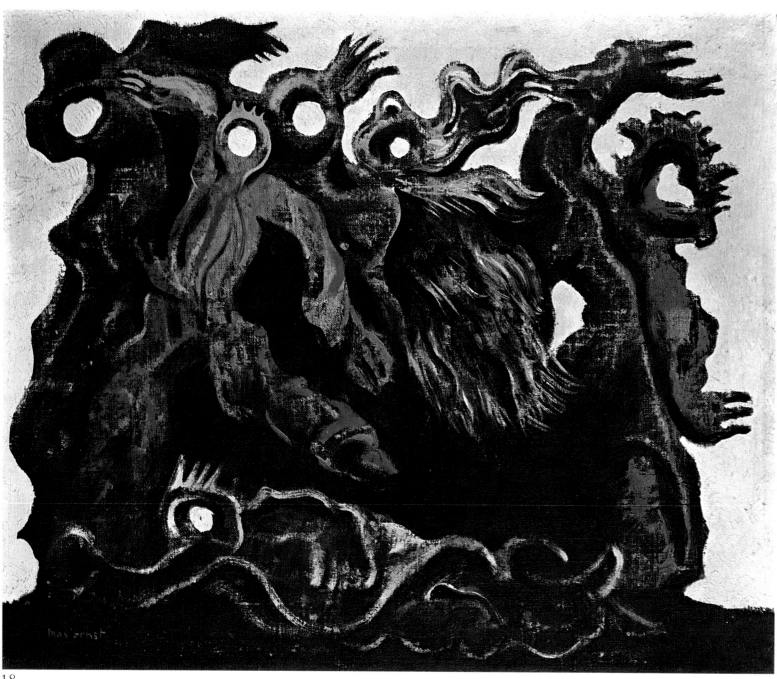

18

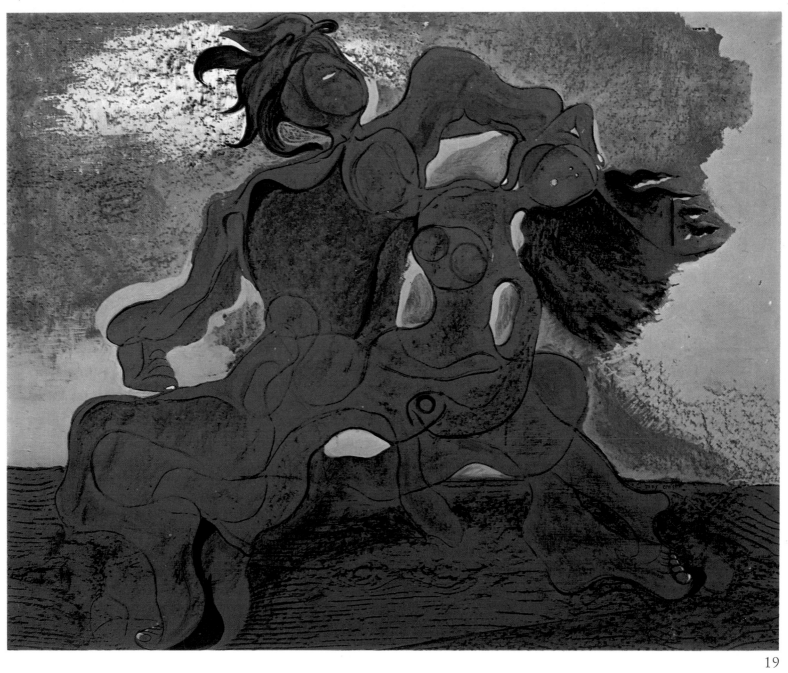

19

20

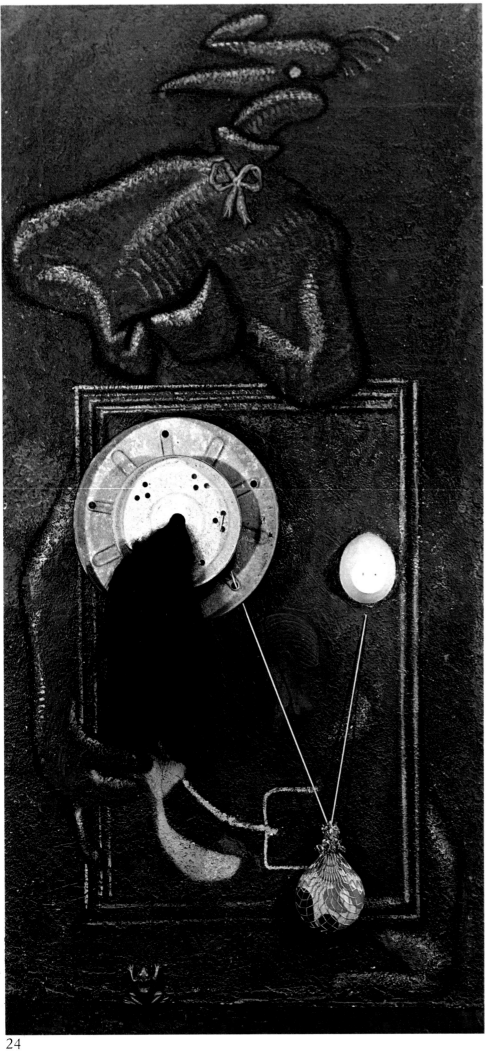

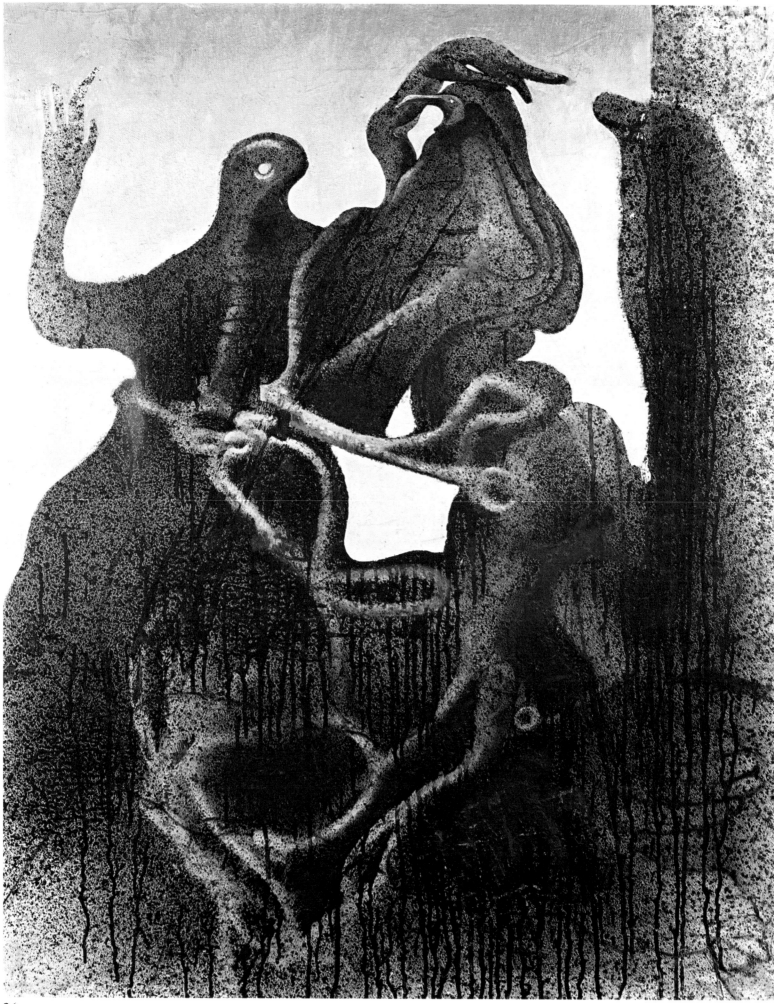

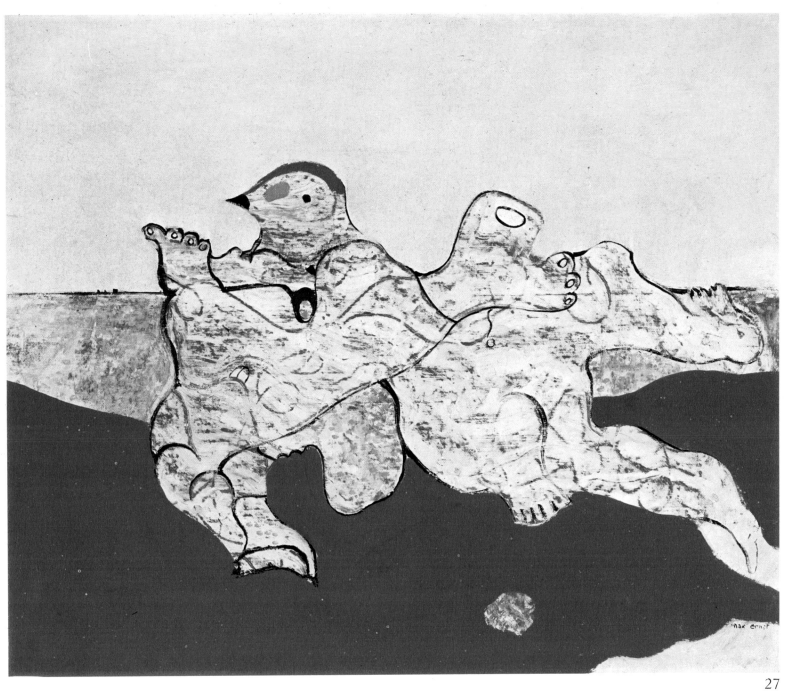

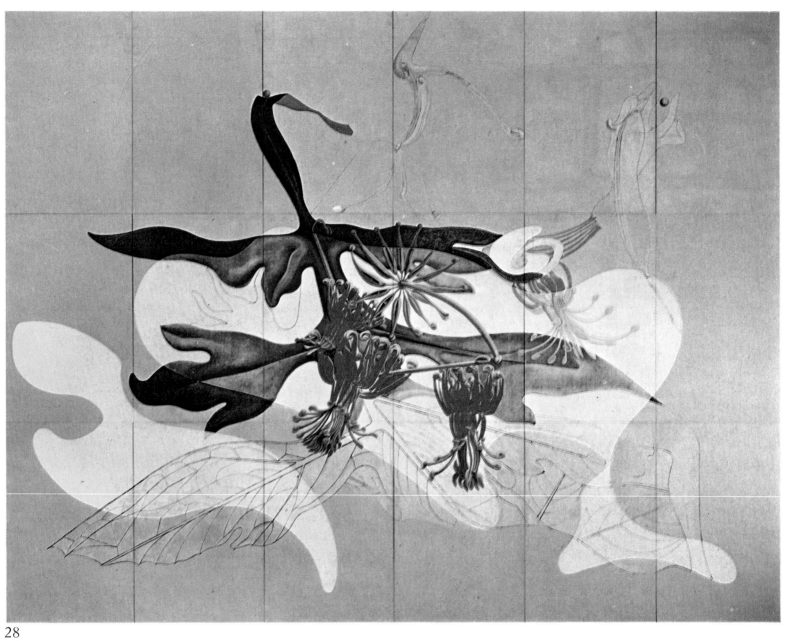

28

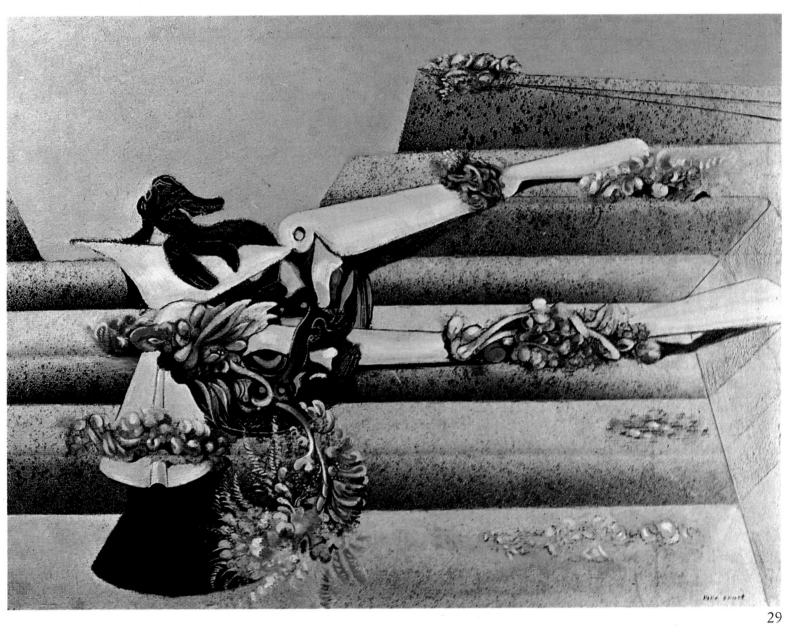

29

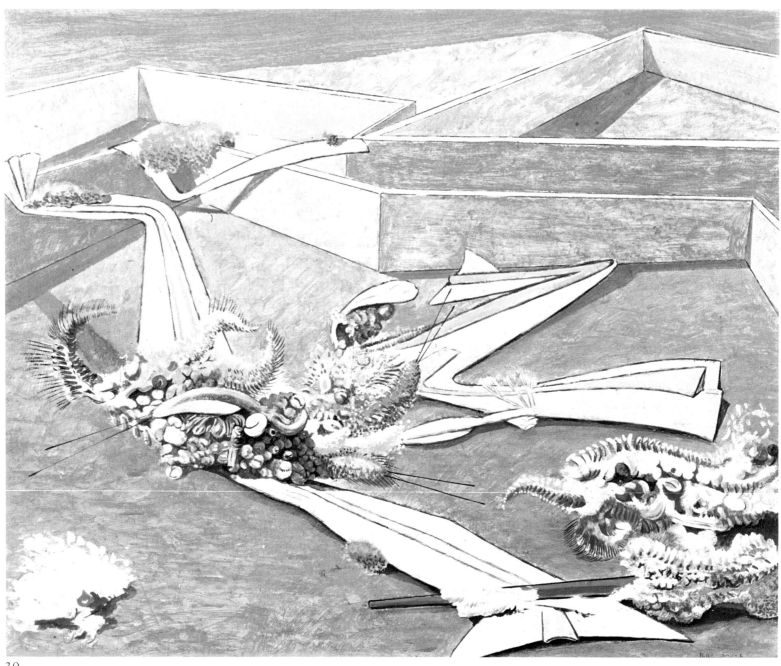

30

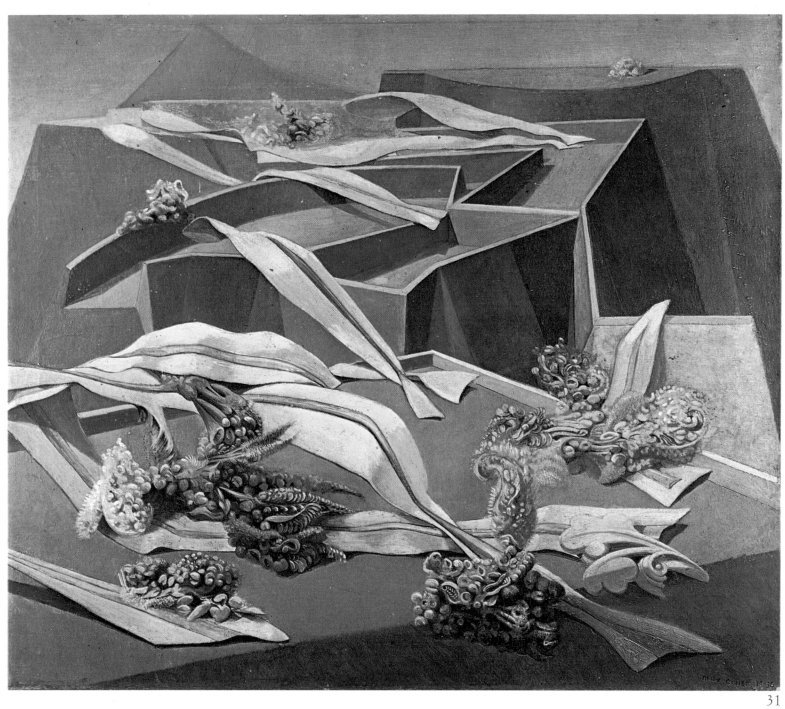

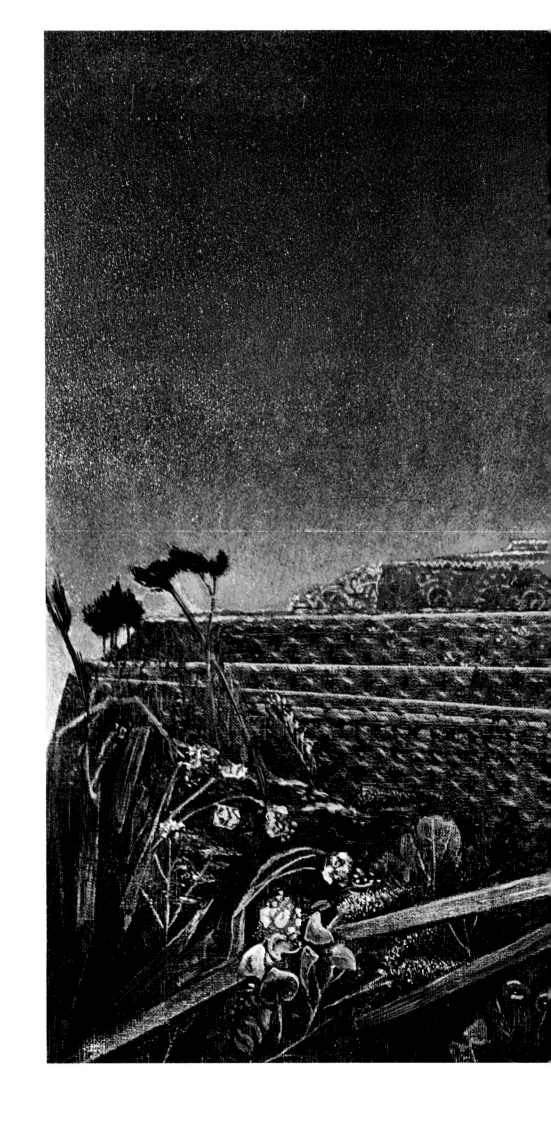

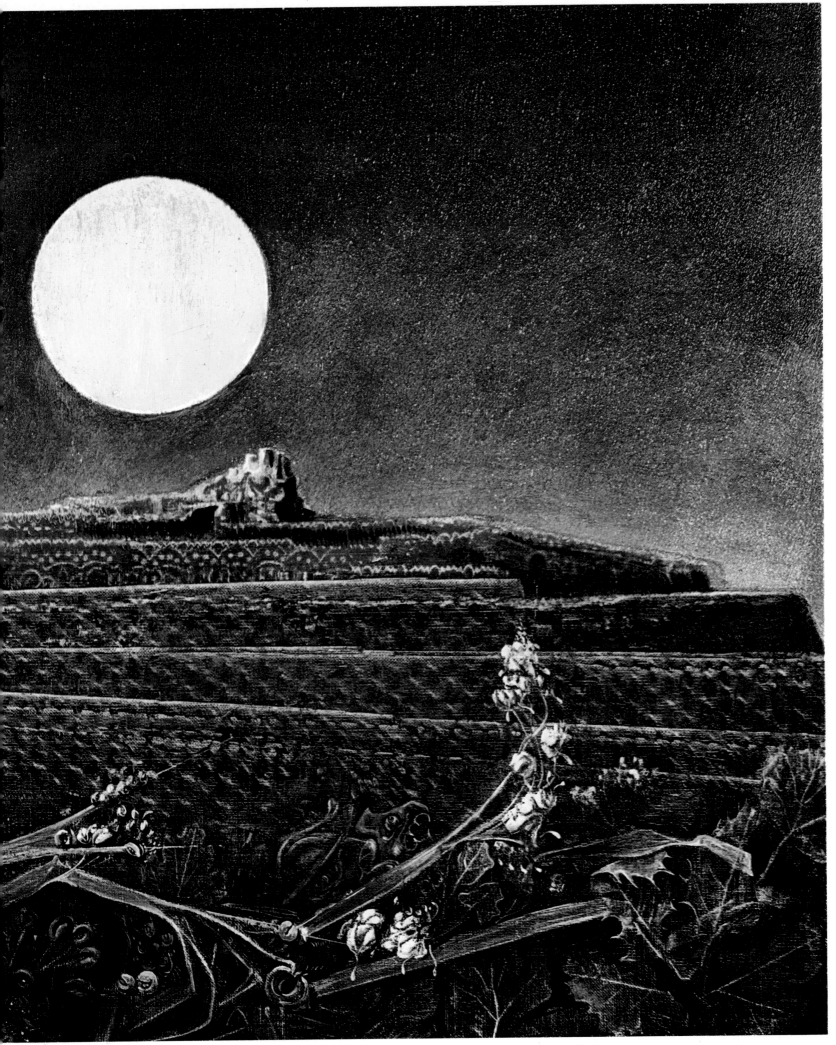

32-33

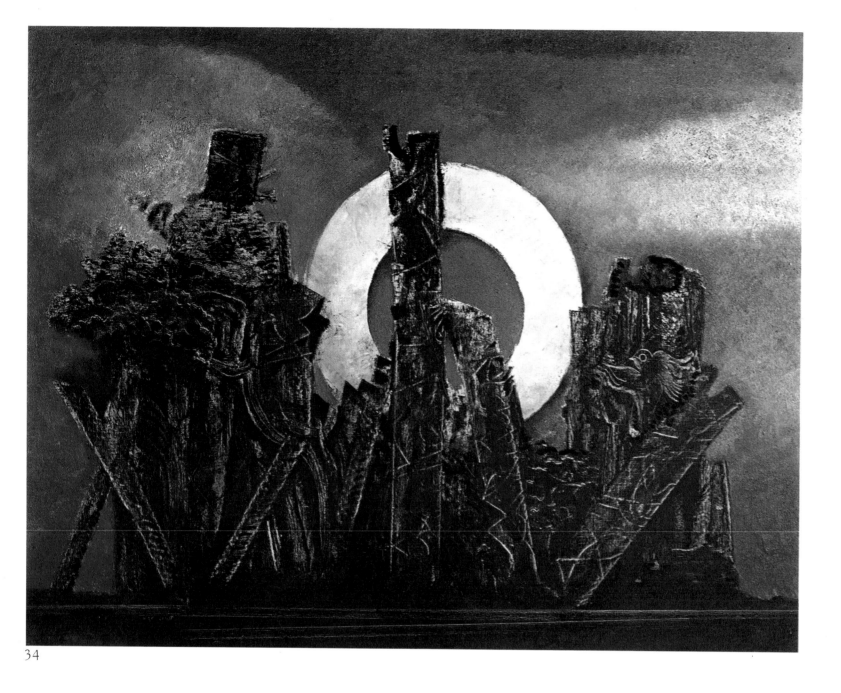

34

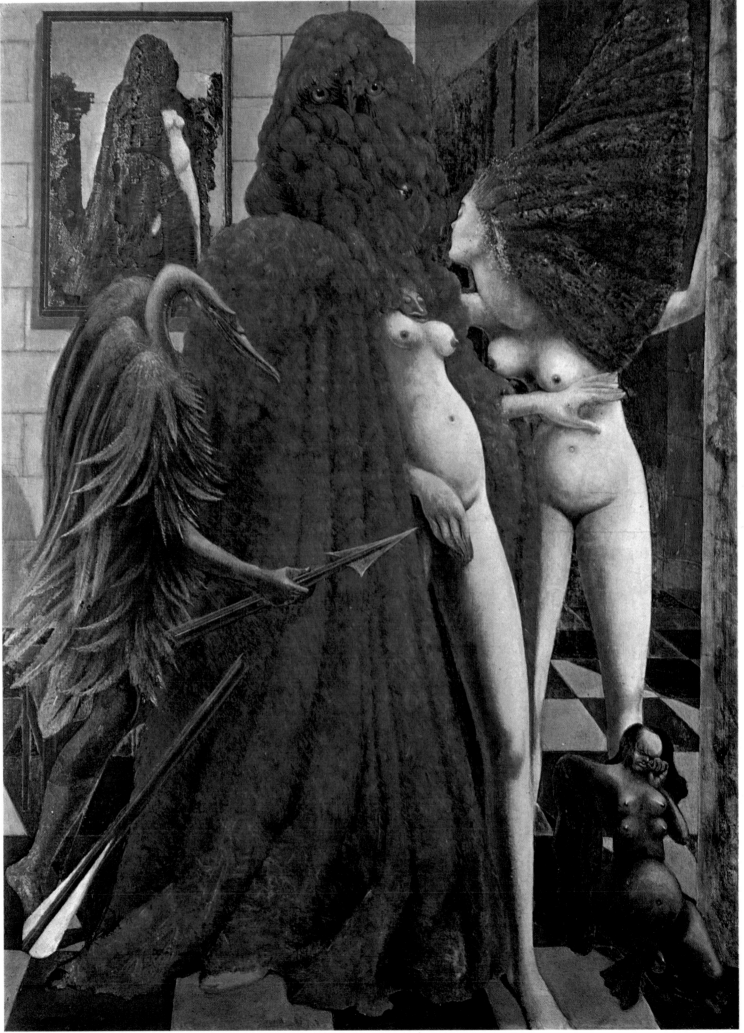

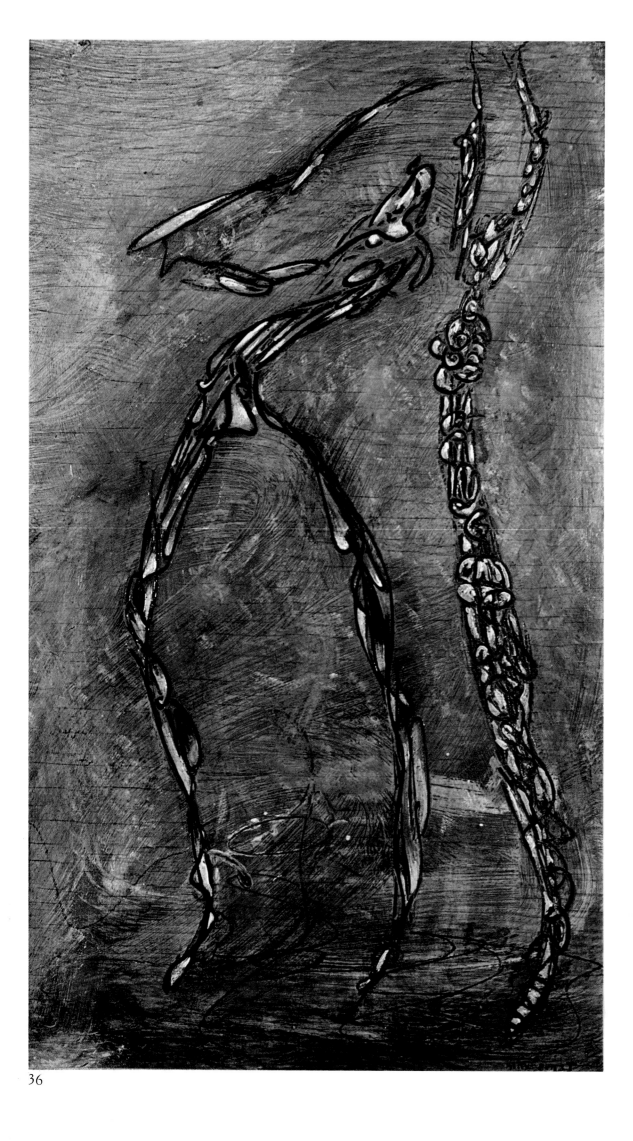

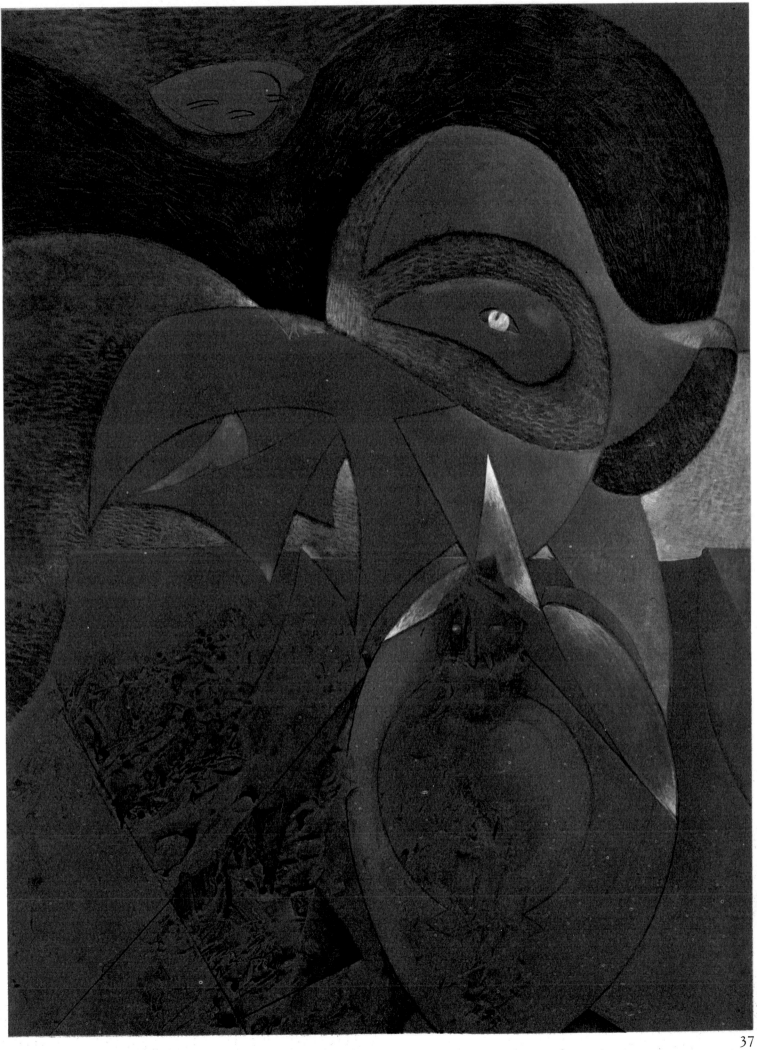

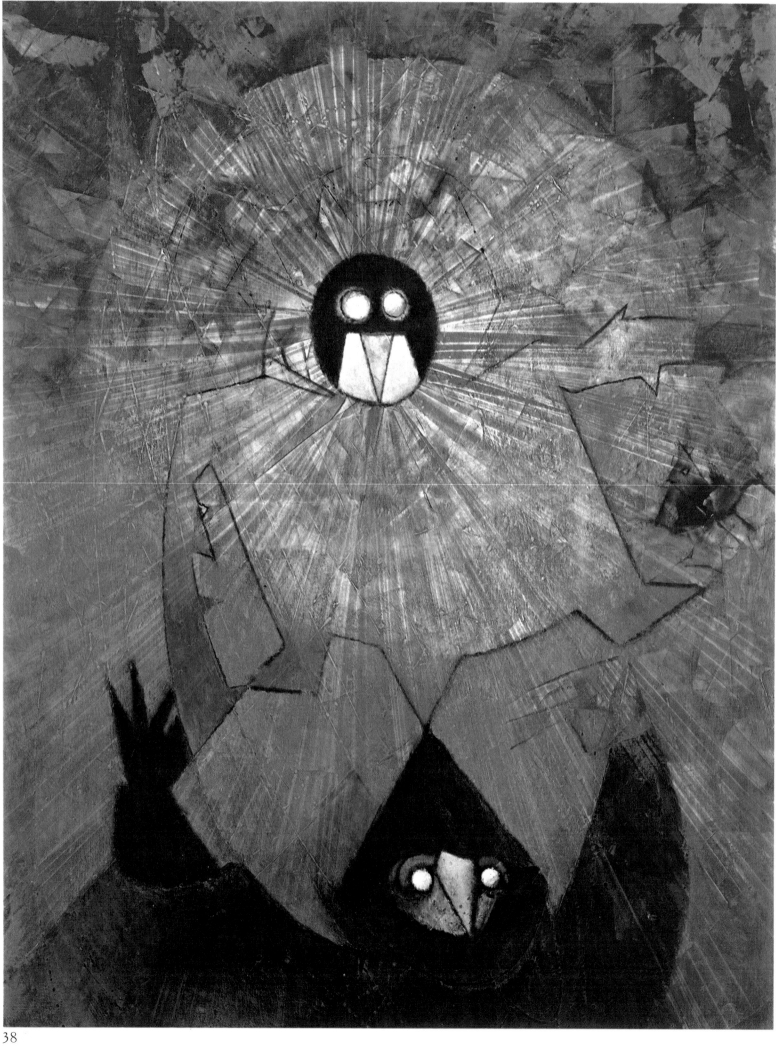

38

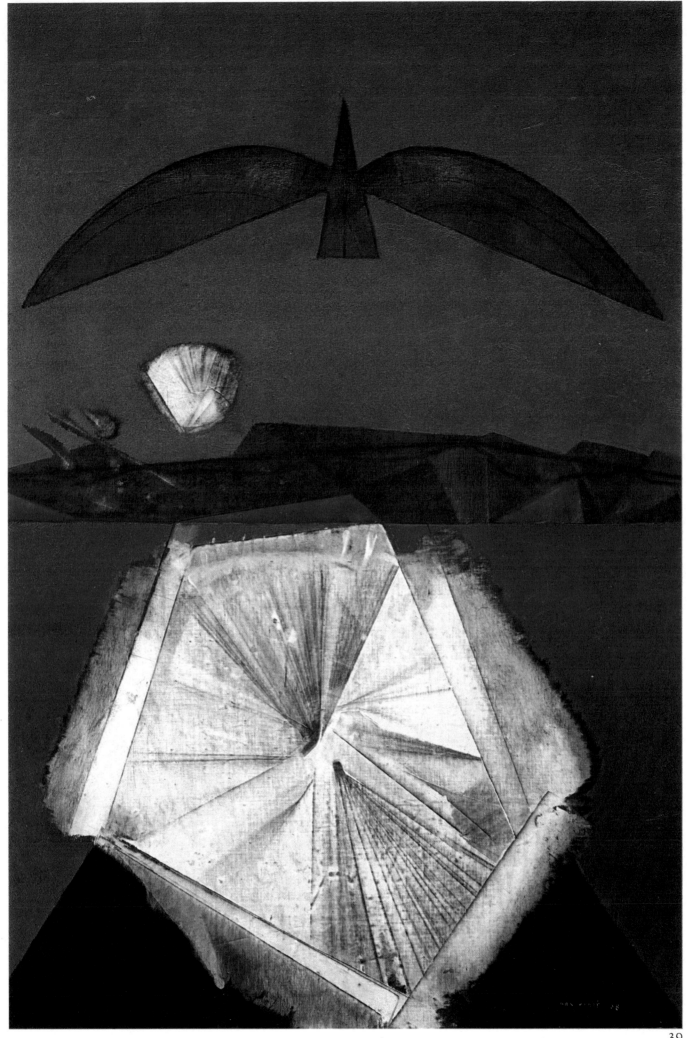

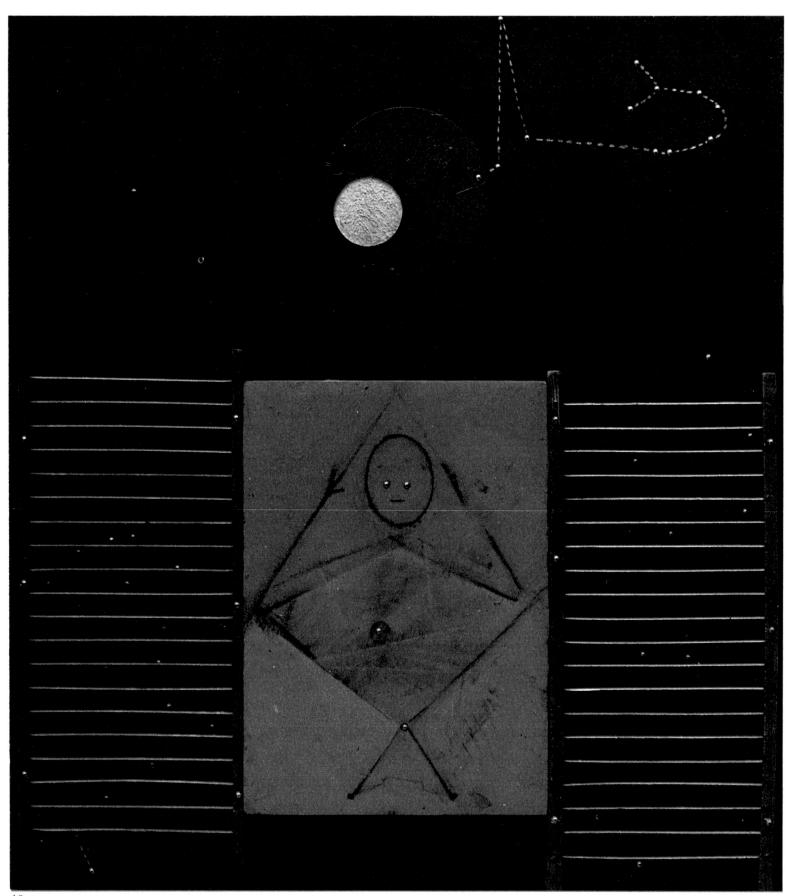

40

Description of colour plates

1 *Holoëder sulfate . . .*
1919, pencil, ink, tempera and collage
Private Collection

2 *Dancing owl*
1919, ink, collage and watercolour, 7 × 9 in (18 × 23 cm)
Private Collection

3 *Design for a poster*
1920, Indian ink, collage, tempera and
watercolour on cardboard, $19\frac{1}{4}$ × 24 in (49 × 60·5 cm)
Galleria d'Arte Moderna, Turin

4 *Untitled*
1920, gouache and collage, 7 × $9\frac{3}{8}$ in (18 × 24 cm)
Private Collection

5 *Katharina ondulata*
1920, collage with gouache and pencil on paper,
$9\frac{3}{4}$ × $11\frac{3}{4}$ in (25 × 30 cm)
Sir Roland Penrose Collection, London

6 *Le chanson de la chair*
1921, photomontage with gouache and pencil,
$4\frac{3}{4}$ × 7 in (12 × 18 cm)
Formerly in André Breton Collection, Paris

7 *Au rendez-vous des amis*
1922. Detail with self-portrait

8–9 *Au rendez-vous des amis*
1922
Lydia Bau Collection, Hamburg

10–11 *Le couple*
1923, oil and collage on canvas, $39\frac{3}{8}$ × $55\frac{7}{8}$ in (100 × 142 cm)
Boymans Museum Rotterdam

12 *The arrival of the travellers*
1922, paper laid down and gouache, $5\frac{1}{2}$ × $4\frac{3}{8}$ in (14 × 11 cm)
Galerie Le Bateau–Lavoir, Paris

13 *Chimera*
1925, oil on canvas, $28\frac{3}{4}$ × $16\frac{1}{2}$ in (73 × 42 cm)
Private Collection

14 *Deux jeunes, filles nues*
1926, oil and frottage on canvas, 33 × $24\frac{1}{2}$ in (84 × 62 cm)
Simone Collinet Collection, Paris

15 *The bird was right*
1926, oil on wood with a collage cage, 13 × $15\frac{3}{4}$ in (33 × 40 cm)
Formerly in Paul Eluard Collection, Paris

16 *The hunter*
1926, oil on canvas, $39\frac{3}{8}$ × $31\frac{7}{8}$ in (100 × 81 cm)
Max Janlet Collection, Brussels

17 *The grey forest*
1927, oil on canvas, $31\frac{7}{8}$ × $39\frac{3}{8}$ in (81 × 100 cm)
Private Collection, Liège

18 *The horde*
1927, oil on canvas, $21\frac{5}{8}$ × $18\frac{1}{8}$ in (55 × 46 cm)
Private Collection

19 *The anger of the red man*
1927, oil on canvas, $31\frac{7}{8}$ × $39\frac{3}{8}$ in (81 × 100 cm)
Mabille Collection, Brussels

20 *Coquillage*
1927, oil and frottage on paper, $16\frac{1}{2}$ × $25\frac{1}{2}$ in (42 × 65 cm)
Private Collection

21 *Gulf Stream*
1927, oil on canvas, $23\frac{1}{4}$ × $28\frac{3}{8}$ in (59 × 72 cm)
Private Collection, Liège

22–23 *Man, a girl's best friend*
1928, oil on canvas, $38\frac{1}{4}$ × $51\frac{1}{4}$ in (97 × 130 cm)
Kunstmuseum Basle

24 *Loplop présente une jeune fille*
1930, plaster and oil on wood, metal, hair, etc.,
$68\frac{7}{8}$ × 35 in (175 × 89 cm)
Private Collection, Paris

25 *Untitled*
1932, oil, pencil and collage $19\frac{3}{4}$ × $25\frac{1}{2}$ in (50 × 65 cm)
Private Collection

26 *Zoomorphic couple*
1933, oil on canvas, $27\frac{1}{2}$ × 35 in (70 × 89 cm)
Peggy Guggenheim Collection, Venice

27 *Le juif au Pole-Nord*
1934
Kunsthaus, Zurich

28 *Wandbild*
1934
Kunsthaus, Zurich

29 *Jardin gobe avions*
1935
Mario Tazzoli Collection, Turin

30 *Jardin gobe avions*
1935
Private Collection, Paris

31 *Jardin gobe avions*
1936
Private Collection, Paris

32–33 *La ville entière*
1935–36, oil on canvas, $23\frac{5}{8}$ × $31\frac{7}{8}$ in (60 × 81 cm)
Kunsthaus, Zurich

34 *The great forest*
1927, oil on canvas, $45\frac{1}{4}$ × $57\frac{7}{8}$ in (115 × 147 cm)
Kunstmuseum, Basle

35 *The robing of the bride*
1939, oil on canvas, $54\frac{3}{4}$ × $37\frac{3}{4}$ in (139 × 96 cm)
Peggy Guggenheim Collection, Venice

36 *The dancers*
1951, oil on canvas, 24 × 14 in (61 × 35·5 cm)
Galleria Schwarz, Milan

37 *Compendium of universal history*
1953
Galleria d'Arte Moderna, Rome

38 *Les dieux obscurs*
1957, oil on canvas, $45\frac{3}{4}$ × 35 in (116 × 89 cm)
Folkwang Museum, Essen

39 *Après moi le sommeil*
1958
Musée National d'Art Moderne, Paris

40 *Le grand ignorant*
detail, 1965, oil and collage on wood, $45\frac{3}{4}$ × $39\frac{3}{8}$ in (116 × 100 cm)
Author's Collection

Biographical outline

It would have been useful to accompany this study with a selection of Max Ernst's writings, in order to give the reader some impression of his exceptional abilities as a writer and poet. Since, however, the scope of this volume does not allow for a comprehensive selection, it was thought appropriate to reprint here an autobiography dictated by the artist himself, combined with notes made in 1959 by Gabrielle Vienne and conversations with William S. Lieberman, who published it—under the title of *An Informal Life of M.E. (as told by himself to a young friend)*—in the catalogue of the Max Ernst exhibition at the Museum of Modern Art in New York in 1961. Several sections of the text which follows first appeared in the pages of *La Révolution Surréaliste, This Quarter, Cahiers d'Art* and *View*. The artist revised them and provided additional notes at the time of the exhibition in New York. Further biographical information is to be found in Ernst's *Beyond Painting*, which was published by Robert Motherwell in 1948. For further study, the reader is directed to the basic studies by Patrick Waldberg (*Max Ernst*, Jean-Jacques Pauvert, Paris, 1958) and John Russell (*Max Ernst*, DuMont Schauberg, Cologne, 1966). In the *Informal Life of M.E.* that follows, the notes in square brackets are those added by William S. Lieberman.

AN INFORMAL LIFE OF M.E.
(as told by himself to a young friend)

1891. First contact with the sensible world: On the second of April at 9:45 a.m. Max Ernst hatched from the egg which his mother had laid in an eagle's nest and over which the bird had brooded for seven years.

It happened in Brühl, six miles south of Cologne. There Max grew up and became a beautiful child. Although marked by some dramatic incidents, his childhood was not particularly unhappy.

In Cologne, at the time of Diocletian, eleven thousand virgins had surrendered their lives rather than their chastity. Their gracious skulls and bones embellish the walls of the convent church in Brühl, the very same place where little Max was forced to spend the most boring hours of his childhood. It may be that their companionship was helpful.

The geographic, political and climatic conditions of Cologne as a city are perhaps propitious to the creation of fertile conflicts in a sensitive child's mind. Many of the important crossroads of European culture meet: influences of the early Mediterranean, Western rationalism, Eastern inclination towards the occult, myths of the North, the Prussian categorical imperative, the ideals of the French Revolution, and so forth. (The continuous and powerful drama of these contradictory tendencies can be recognized in M.E.'s work. One day, perhaps, elements of a new mythology will spring from this drama.)

[Parents: Louise Kopp and Philipp Ernst, the latter a painter as well as a teacher at the School for the Deaf and Dumb for the Rhine province, in Brühl.]

1894. First contact with painting: The child watched the father at work on a small watercolor entitled *Solitude* which represented a hermit, seated in a beech forest, reading a book. Something both peaceful and menacing emanated from this *Solitude*—perhaps because of the subject (unusual in spite of its simplicity) or because of the way in which it was treated. Each of the countless leaves, stirred by branches of the tree, had been delineated with obsessive solicitude; each seemed endowed with a separate and solitary life. In the painting the hermit appeared seated somewhere beyond this world and his supernatural air both thrilled and frightened little Max. Even the very sound of the word "hermit" as pronounced by the father disturbed the child, who repeated the syllables in awkward intonations until all sense disappeared.

Max never forgot the enchantment and terror he felt when, for the first time a few days later, the father led him into the forest. (Echoes of this feeling can be found in many of M.E.'s own *Forests, Visions, Suns* and *Nights*.)

1896. First contact with drawing: Little Max made a series of drawings. They represented the father, mother, sister Maria (one year older than himself), two younger sisters, a friend and the station master of the railroad. In the sky—a train, abundantly smoking.

When asked, 'What will you be when you grow up?' he always answered, 'a railroad station master.' Maybe the child was seduced by the nostalgia evoked by passing trains, or by the great mystery of telegraph wires which move when watched from a moving train yet stay still when you stand still.

One night, to explore the mystery of telegraph wires (and also to flee from the father's tyranny), five-year-old Max escaped from his parents' house. Blond, blue-eyed and curly-haired, he joined (by chance) a procession of pilgrims. Enchanted by the apparition of this charming child, the pilgrims proclaimed him 'little Jesus Christ'. To appease his father's wrath (the next day when a policeman brought him home) little Max declared he *was* the Christ Child. This candid remark inspired the father to paint a portrait of little son as little Jesus.

1897. First contact with nothingness: His sister Maria kissed him and her sisters goodbye and, a few hours later, died. After this the feeling of nothingness and the powers of destruction were utmost in his mind, in his behaviour and, later, in his work.

First contact with hallucination: Measles and powers of destruction. A fever vision: *I see before me a panel crudely painted with large black strokes on a red background imitating the grain of mahogany and provoking associations of organic forms—a threatening eye, a long nose, the enormous head of a bird with thick black hair, and so forth. In front of the panel a shiny black man makes slow, comic and, according to the memories of a time long past, joyously obscene gestures. This odd fellow wears my father's moustaches. After several leaps in slow motion which revolt me, legs spread, knees folded, torso bent, he smiles and takes from his pocket a big crayon made from some soft material which I cannot more precisely describe. He sets to work. Breathing loudly he hastily traces black lines on the imitation mahogany. Quickly he gives it new, surprising and despicable forms. He exaggerates the resemblance to ferocious and viscous animals to such an extent that they become alive, inspiring me with horror and anguish. Satisfied with his art, the man seizes and gathers his creations into a kind of vase which, for this purpose, he paints in the air. He whirls the contents of the vase by moving his crayon faster and faster. The vase ends up by spinning and becomes a top. The crayon becomes a whip. Now I realize that this strange painter is my father. With all his might he wields the whip and accompanies his movements with terrible gasps of breath, blasts from an enormous and enraged locomotive. With a passion that is frantic, he makes the top jump and spin around my bed.*

Certainly little Max took pleasure in being frightened by these somnolescent visions and later voluntarily provoked hallucinations of the same kind by looking at wood panellings, clouds, wallpapers, unplastered walls, and so forth, to release his imagination. When asked, 'What is your favorite occupation?' he always answered 'seeing'.

1898. Second contact with painting: He watched the father begin a picture in the garden *après nature* and finish it in his studio. The father omitted a tree which disturbed the composition. When he had finished the painting he went out and chopped down the tree so that no longer would there exist any difference between nature and art. Against such strict realism revolt grew in the child's heart. He decided to direct himself towards a more equitable conception of the relationship between the subjective and the objective world.

Duties at school were already odious. Indeed the very sound of the word *Pflicht* always inspired M.E. with horror and disgust. However, what the professors (of theology and ethics) named the three sources of evil—the pleasures of the eye, the pleasures of the flesh, the vanities of life—proved irresistibly attractive. (Since the cradle M.E. has neglected duties to surrender himself to the three sources of evil. Among them the pleasures of the eye have dominated.)

1906. First contact with the occult, magic and witchcraft: On the night of the fifth of January one of his closest friends, a most intelligent and affectionate pink cockatoo, died. It was a terrible shock to

Max when, in the morning, he discovered the dead body and when, at the same moment, the father announced the birth of a sister.

In his imagination Max coupled these two events and charged the baby with the extinction of the bird's life. There followed a series of mystical crises, fits of hysteria, exaltations and depressions. A dangerous confusion between birds and humans became fixed in his mind and asserted itself in his drawings and paintings. (Later M.E. identified himself voluntarily with *Loplop, Bird Superior.* This phantom remained inseparable from another—*Perturbation, my Sister: the Hundred Headless Woman.*)

Excursions into the world of marvels, chimeras, phantoms, poets, monsters, philosophers, birds, women, lunatics, magi, trees, eroticism, poisons, mathematics, and so forth. A book that he wrote at this time the father found and burned. The title was *Divers' Manual.*

At the age of adolescence, the well-known game of purely imaginary occurrences seen in somnolescence: *A procession of men and women, attired in everyday dress, come from a distant horizon towards my bed. Before arriving, they separate: the women pass to the right, the men to the left. Curious, I lean toward the right so that not a single face will escape me. At first I am struck by the extreme youth of all these women, but, upon close examination face by face, I realize my mistake—many are middle-aged and only two or three are very young, about eighteen years old, the age convenient to my adolescense. I am too occupied with these women to pay much attention to what passes on the left. But without seeing I know that there I would make the opposite error. All these men begin to shock me because of their precocious senility and remarkable ugliness, but among them, upon close examination, only my father continues to have the features of an old man.*

1909. [Receives his baccalaureate. Plans a degree in philosophy at the University of Bonn with the intention of specializing in psychiatry.] As his family obliged Max to continue his studies, he was enrolled at the University of Bonn. He followed, however, the path on which he had embarked at the *gymnasium*: neglected duties to surrender passionately to the most gratuitous activity there is—painting.

His eyes were avid not only for the amazing world which assailed them from the exterior but also for that other world, mysterious and disquieting, which burst forth and vanished in adolescent dreams with persistence and regularity: *To see it clearly becomes a necessity for my nervous equilibrium. To see it clearly there is only one way—to record all offered to my sight.*

1910–1911. The young man, eager for knowledge, avoided any studies which might degenerate into breadwinning. Instead his pursuits were those considered futile by his professors—predominantly painting. Other futile pursuits: reading seditious philosophers and unorthodox poetry, transient pleasures, and so forth. Attracted by the most audacious spirits, he was willing to receive the most contradictory influences—in painting, for example—Manet, Gauguin, van Gogh, Goya, Macke, Kandinsky, Delaunay, and so forth.

What to do about consequent confusion? Struggle like a blind swimmer? Appeal to reason? Submit to discipline? Or, accentuate contradictions to the point of paroxysm? Should he abandon himself in his night, indulge in the luxury of losing reason? The young man's temperament predisposed him to accept the last solution.

[In the course of his studies visits asylums and, for the first time, sees the art of the insane about which he decides to write a book.] Near Bonn there was a group of sinister looking buildings resembling, in many ways, the Hospital of St. Anne in Paris. At this 'clinic for the mentally ill', students could take courses and practical jobs. One of the buildings housed an astonishing collection of sculpture and paintings executed in spite of themselves by the inmates of this horrible place. These works strongly touched and troubled the young man. *I try to recognize streaks of genius in them and decide to explore fully those vague and dangerous lands confined by madness.* (But it was only much later that M.E. discovered certain processes which helped him venture into these no-man's lands.)

Meets August Macke, a subtle poet, the very image of just and intelligent enthusiasm, generosity, judgement and exuberance. [Macke, himself influenced by Robert Delaunay, lived in Bonn.

With Wassily Kandinsky, Franz Marc, Alexei Jawlensky and Paul Klee, he was a member of *Der Blaue Reiter* in Munich. Macke was also associated with the group around Herwarth Walden, dealer and publisher of *Der Sturm* in Berlin, as well as with avant-garde painters and poets in France and Germany. He was killed in 1914.]

1912. [M.E. joins *Das Junge Rheinland,* a group of friends, poets and painters stimulated to a great extent by Macke.] We were filled with heroism. Spontaneity was *de rigeur.* No doctrine, no discipline, no duties to fulfil. United by a thirst for life, poetry, liberty, the absolute and knowledge. *C'était trop beau....* [Decides he is a painter. Sees the Cologne Sonderbund exhibition which includes van Gogh, Cézanne, Munch and Picasso. Meets Munch.]

[First exhibitions: 1912, at the informal galleries of *Das Junge Rheinland* in the bookshop of Friedrich Cohen, Bonn; at the Feldmann Gallery, Cologne; 1913, at the Gereon Club, Cologne; at the *Erst Deutsche Herbstsalon,* Berlin—the last, a group exhibition presented by *De Sturm* and organized by Macke and Kandinsky, includes work by Chagall, Delaunay and Klee.]

1913. [Meets Guillaume Apollinaire, accompanied by Delaunay.] It was only once at Macke's house. Needless to say M.E. was deeply moved. What he had read had dazzled and excited him. 'Zône' had appeared in *Der Sturm;* and the first edition of *Alcools,* published by Mercure de France with a Picasso drawing, had arrived in Cologne. We were speechless, utterly captivated by Apollinaire's winged words which flew from the lightest to the most serious, from deep emotion to laughter, from paradox to incisively accurate formulation.

First contact with Paris, the third week of August: Armed with a light suitcase arrived at the Gare du Nord, scorned the cabs, took the Boulevard de Strasbourg, then Sébastopol, slowing down at intersections, cafés, store-fronts, eyes bulging, lying in wait. Arrived at Les Halles. Refreshed after a bowl of soup and a horn of *frites,* wandered around and felt right. Rented a room, Hôtel des Ducs de Bourgogne, the rue de Pont Neuf, leaned out the window, saw the Seine. (Macke had given letters; looked up no one.) Happy to wander all day in different *quartiers.* At night theatres, dance halls and cabarets. Went often to Montparnasse where, at the Café Dôme, met Jules Pascin. At the end of four weeks, money gone, had to leave. (In Paris, M.E. had experienced that feeling of *belonging* which, as Patrick Waldberg reminds us, is like love at first sight and binds forever.)

1914. First contact with Arp: One day in Cologne M.E. noticed someone about his own age in a gallery which showed works by Cézanne, Derain, Braque and Picasso. His face was handsome and spiritual, his manners courtly. However they contrasted strangely with what he was doing. With gentleness (Franciscan) and competence (Voltairian), he seriously was attempting to explain to an old fool the virtues of modern art. The imbecile pretended to be convinced but exploded with rage when Arp showed him some of his own drawings. With shouts and gestures he announced that he was seventy-two, that his whole life and strength had been devoted to art and that, if this were the result of all his sacrifices, it would be better. . . . Quietly Arp suggested that it would be better—to ascend to heaven. Pronouncing maledictions the fool left; M.E. and Arp joined hands to conclude a pact of friendship still vigorous today.

On the first of August 1914 M.E. died. He was resurrected on the eleventh of November 1918 as a young man who aspired to find the myths of his time. Occasionally he consulted the eagle who had brooded the egg of his prenatal life. (You may find the bird's advice in his works.)

[War: Four years at the front as an artillery engineer. At the front twice wounded, by the recoil of a gun, by the kick of a mule. His fellow soldiers named him 'the man with the head of iron'. Invalided 1917. In February, M.E. and Paul Eluard, not yet acquainted, had fought on the same front, opposite sides.]

How to overcome the disgust and fatal boredom that military life and the horrors of war create? Howl? Blaspheme? Vomit? Or, have faith in the therapeutic virtues of a contemplative life? Circumstances were not favourable. However, he decided to make

an attempt. A few watercolours, even paintings (executed in moments of calm) attest this. Many of these, lost or destroyed, already contained the germ of later works (*Histoire Naturelle*, 1925). A few titles, still remembered, indicate a state of mind: *Desire of a plant to cling, Of love in the inanimate world, Descent of animals into the valley at night, A leaf unfolds,* and so forth.

1916. [DADA is born in Zurich. *Der Sturm* organizes a small exhibition of M.E.'s work in January and publishes a drawing as cover of the periodical, vol. 6, no. 19/20.]

1917. [*Der Sturm* publishes 'On the Development of Colour', an article by M.E.].

1918. [DADA arrives in Germany. M.E. marries Louise Strauss, a student of art history.]

1919. [On a trip to Munich M.E. sees DADA publications from Zurich and discovers that Arp is alive. In Munich M.E. also sees an exhibition of Klee whom he visits for the first and last time. In the magazine *Valori Plastici*, he sees the work of de Chirico and, as a result, creates the album of eight lithographs *Fiat Modes Pereat Ars*. M.E. composes his first altered engravings and collages.]

Enter, enter, have no fear of being blinded–One rainy day in 1919 in a town on the Rhine, my excited gaze is provoked by the pages of a printed catalogue. The advertisements illustrate objects relating to anthropological, microscopical, psychological, mineralogical and paleontological research. Here I discover the elements of a figuration so remote that its very absurdity provokes in me a sudden intensification of my faculties of sight–a hallucinatory succession of contradictory images, double, triple, multiple, superimposed upon each other with the persistence and rapidity characteristic of amorous memories and visions of somnolescence. These images, in turn, provoke new planes of understanding. They encounter an unknown –new and non-conformist. By simply painting or drawing, it suffices to add to the illustrations a colour, a line, a landscape foreign to the objects represented–a desert, a sky, a geological section, a floor, a single straight horizontal expressing the horizon, and so forth. These changes, no more than docile reproductions of what is visible within me, record a faithful and fixed image of my hallucination. They transform the banal pages of advertisement into dramas which reveal my most secret desires.

[Dadamax Ernst and J. T. Baargeld form the DADA conspiracy in the Rhineland and, with others, a DADA centre, W/3 West Stupidia. They publish *Der Ventilator*, banned by the British army of occupation, also *Bulletin D,* and arrange the first DADA exhibition in Cologne.]

1920. *Der Arp ist da.* [Cologne: February, first issue of *Die Schammade* edited by Dadamax and Baargeld. Arp had returned and joined them. He and M.E. produce *Fatagaga* (*fabrication de tableaux garantis gazométriques*). April: Second, culminating DADA exhibition–*DADA Ausstellung DADA Vorfrühling*. Meets Kurt Schwitters. Birth of a son, Jimmy.]

[Paris: First contact with André Breton: Dadamax is invited to exhibit his collages. In May, the exhibition opens *Au sans pareil*.]

1921. [Cologne: Eluard, accompanied by his wife Gala, visits Cologne and selects collages as illustrations to his poems. Dadamax signs *DADA soulève tout,* a DADA manifesto.]

[Tyrol: Summers at Tarrenz-bei-Imst with Arp, Sophie Taeuber, Tristan Tzara and, for the last time, Louise Ernst. Contributions, 'Dada au grand air' to DADA Tyrol issue of DADA magazine.]

1922. [Summer: Again, in the Tyrol.] August: Born and bred in the Rhineland, escaped, with neither papers nor money, to Paris to live. [Settles in Saint Brice, a suburb near Montmorency, in the same building with Eluard. Works in an atelier which manufactures souvenirs of Paris. Publication of *Les Malheurs des Immortels,* and *Répétitions,* two collaborative volumes, collages by M.E., poems by Eluard.]

1923. [Paints: *Equivocal Woman, Saint Cecelia, The Couple,* and the first version of *Woman, Old Man and Flower.* The last, completely repainted the following year. The woman, of course, lies in the old man's arm. The other figure is the flower.

1924. *Two Children Are Threatened by a Nightingale,* the last in the series which started with *Elephant of the Celebes, Oedipus Rex, Revolution by Night, La Belle Jardinière* [destroyed] and, probably, the last consequence of his early collages–a kind of farewell to a

technique and to occidental culture. (This painting, it may be interesting to note, was very rare in M.E.'s work: He never imposes a title on a painting. He waits until a title imposes itself. Here, however, the title existed *before* the picture was painted. A few days before he had written a prose poem which began: *à la tombée de la nuit, à la lisière de la ville, deux enfants sont menacés par un rossignol....* He did not attempt to illustrate this poem, but that is the way it happened.)

[M.E. sells all of his work in Germany, sails in July for the Far East. M.E., Gala and Eluard are rejoined in Saigon. M.E. spends about three months travelling, returns via Marseilles. Breton's first Surrealist Manifesto, issued in Paris October.] M.E. found his friends in Paris *en plein effervescence.*

1925. On the tenth of August (in Pornic, the home of Gilles de Laval), M.E. found a process which rests solely upon the intensification of the mind's powers of irritability. In view of the characteristics of its technique, he called it *frottage* [rubbing] and, in his own personal development, it has had an even larger share than collage from which, indeed, he believes it does not fundamentally differ. By means of appropriate techniques, by excluding all conscious mental influences (of reason, taste or morals) and by reducing to a minimum the active part of what, until now has been called the 'author', this process revealed itself as the exact equivalent of what was known as automatic writing. By enlarging the active part of the mind's hallucinatory faculties, he succeeded in attending, simply as a spectator, the birth of his works.

Enter, enter, have no fear of being blinded–One rainy day at an inn by the seaside, I discover myself recalling how in childhood the panel of imitation mahogany opposite my bed had served as the optical stimulant to visions in somnolence. Now I am impressed by the obsession imposed upon my excited gaze by the wooden floor, the grain of which had been deepened and exposed by countless scrubbings. I decide to investigate the symbolism of this obsession and, to aid my meditative and hallucinatory powers, I take from the boards a series of drawings. At random I drop pieces of paper on the floor and then rub them with black lead. By examining closely the drawings thus obtained, I am surprised at the sudden intensification of my visionary capacities.

My curiosity awakened, I marvel and am led to examine in the same way, all sorts of materials that fall into my field of vision–leaves and their veins, the ragged edges of sack cloth, the palette knife's markings on a 'modern' painting, thread unrolled from its spool and so forth–that end with a kiss (the Bride of the Wind).

Drawings obtained in this way–thanks to a progression of suggestions and transmutations which occur spontaneously (like hypnagogical visions)–lost the character of the material employed, here for example wood, and assumed the aspect of unbelievably precise images which were probably able to reveal the initial cause of the obsession or to produce some semblance of its cause.

These drawings, these first fruits of frottage, were assembled as *Histoire Naturelle* from *The Sea and the Rain* to *Eve, the Only One Left.* [Their titles]: *The Sea and the Rain–A Glance–Little tables around the earth–Shawl of Snow Flakes–Earthquake–Pampas–He will fall far from here–False Positions–Confidences–She guards her secret–Whip lashes or lava threads–Fields of Honour, Inundations, Seismic Plants–Scarecrows–Sprint of the Chestnut Tree–Scars–The linden tree is docile–The Fascinating Cypress–Habits of Leaves–Idol–The Palette of Caesar–Huddling against the walls–Enter into the continents–Vaccinated Bread–Flashes of lightning under fourteen years old–Conjugal Diamonds–Origin of the Clock–In the stable of the sphinx–Dead Man's Meal–Wheel of Light–He who Escaped–System of Solar Money–To Forget Everything–Stallion and the Wind's Betrothed–Eve, the Only One Left.*]

At first it seemed frottage could be used only for drawings. Then M.E. adapted it to painting. It revealed a field of vision limited only by the capacity of irritability of the mind's powers.

[Many of the 'natural history' frottages published as a portfolio the following year, preface by Arp, bibl. 12. Contributes to the first Surrealist group exhibition at the Galerie Pierre, Paris. Autumn: Roland Penrose sees *La Belle Jardinière* by M.E. reproduced in the magazine *La Révolution Surréaliste.* They meet.]

1926. *January: I see myself lying in bed and, at my feet, standing, a tall thin woman, dressed in a very red gown. The gown is transparent, so is the woman. I am enchanted by the surprising elegance of her bone structure. I am tempted to pay her a compliment.*

[M.E. and Joan Miró collaborate on the ballet *Roméo et Juliette* for Diaghilev. As a result, a broadside signed by Breton and Louis Aragon condemns them for unsurrealist activities. *Roméo et Juliette*, a ballet in two tableaux, first presented by the Ballets Russes at the Théâtre de Monte Carlo, May 4. Music by Constant Lambert; decors and costumes by M.E. and Miró; choreography by Bronia Nijinska.]

1927. [January in Megève. February returns to Paris. Meets and marries Marie-Berthe Aurenche without her parents' blessing. Paints *Young People Trampling Their Mother; Vision Provoked by a String Found on My Table; The Horde; Vision Provoked by the Nocturnal Aspects of the Porte St. Denis; One Night of Love.*

1928. *Entrance of the flowers:* Aux rendez-vous des amis.... C'était la belle saison.... *It is the time of serpents, earthworms, feather flowers, shell flowers, bird flowers, animal flowers, tube flowers. It is the time when the forest takes wing and flowers struggle under water. (Was he not a pretty flower?) It is the time of the circumflex medusa.*

[Publication of Breton's *Le Surréalisme et la Peinture*, reproducing among other works by M.E.: *The Little Tear Gland That Says Tic-Tac, Revolution by Night, Two Children Are Threatened by a Nightingale, Young People Trampling Their Mother.*]

1929. One day a painter asked M.E., 'What are you doing now, are you working?' 'Yes,' he replied, 'I am making collages. I am preparing a book which will be called *The Hundred Headless Woman.*'

The acquaintance whispered in his ear, 'And what sort of glue are you using?' With that modest air which his contemporaries so admire, he admitted that in most of his collages, there is little use for glue; that he is not responsible for the term 'collage', that of fifty-six of the catalogue numbers of his exhibition of 'collages' in 1920, only twelve justified the term *collage-découpage*. As for the other forty-four, Aragon was right when he said 'the place to catch the thoughts of M.E. is the place where, with a little colour, a line of pencil, he ventures to acclimate the phantom which he has just precipitated into a foreign landscape.' Maxim: If it is not plumes that make plumage, it is not glue [*colle*] that makes collage. [Meets Alberto Giacometti. Publication of M.E.'s collage novel *La Femme 100 têtes.*]

1930. *After having composed with method and violence my novel* The Hundred Headless Woman, *I am visited almost daily by the Bird Superior, Loplop—my private phantom. He presents me with a heart in a cage, the sea in a cage, two petals, three leaves, a flower and a young girl. Also, the man of the black eggs and the man with the red cape.*

One beautiful autumn afternoon he relates that he had once invited a Lacedemonian to come and listen to a man who imitated perfectly the nightingale. The Lacedemonian replied, 'I have often heard the nightingale itself'.

One evening he tells some maxims, which don't make me laugh. Maxim: it is better not to reward a beautiful deed than to reward it badly. Illustration: A soldier lost both arms in battle. His colonel offered him a silver dollar. Said the soldier, 'No doubt you think, sir, that I have lost a pair of gloves'.

[The collage novel by M.E., *Rêve d'une petite fille qui voulut entrer au Carmel*, published, July: The film *L'Age d'Or* by Luis Buñuel and Salvador Dali, in part inspired by M.E.'s pictures, is privately shown at the home of the Vicomte de Noailles. M.E., himself, appears in the film.]

1931. [Nine paintings by the German romantic Caspar David Friedrich, destroyed by fire while on exhibition at the Glass Palace, Munich. Patrick Waldberg describes effect of this destruction upon M.E.: 'He felt the loss to the point of sickness. Beyond painting, profound spiritual ties united him—beyond time—to this poet-artist in whom his own preoccupations discovered a kindred echo. Caspar David Friedrich had said: "Close your physical eyes in order to see first your painting with the spiritual eye. Next, bring into the daylight what you have seen in your night so that your action is exercised in turn on other beings from the exterior to the interior.'

M.E. has never ceased to follow this advice.']

[First exhibition in the United States: Julien Levy Gallery, New York.]

1932. [Finishes series of collages, *Loplop introduces . . .* , begun in 1929.]

1933. [In the early summer visits northern Italy: Le Roncoli, Vigoleno and Ravenna. Paints the largest of his forest pictures, cat. no. 63 and, the next year for the magazine *Minotaure*, bibl. 4, writes:] *What is a forest? A supernatural insect. A drawing board. What do forests do? They never retire early. They await the woodcutter. What is summer for the forests? The future: that will be the season when masses of shadows will be able to change themselves into words and when beings gifted with eloquence will have the nerve to seek midnight at zero o'clock.*

But that is time past, it seems to me. Perhaps.

In that time past did nightingales believe in God? In that time past nightingales did not believe in God. They were bound in friendship to mystery.

And man, what position was he in? Man and the nightingale found themselves in the most favourable position for imagining: they had in the forest a perfect guide to dreams.

What is dreaming? You ask of me too much; it is a woman who fells a tree.

What are forests for? To make gifts of matches to children as toys.

Is, then, fire in the forest? Fire is in the forest.

What do the plants live on? Mystery.

What day is it? Merde.

What will be the death of the forests? The day will come when a forest, until then a friend of dissipation, will decide to frequent only sober places, tarred roads and Sunday strollers. She will live on pickled newspapers. Affected by virtue, she will correct these bad habits contracted in her youth. She will become geometric, conscientious, dutiful, grammatical, judicial, pastoral, ecclesiastical, constructivist and republican. . . . It will be a bore. Will the weather be fair? Of course! We'll go on a presidential hunt.

Will the name of this forest be Blastula or Gastrula? Her name will be Mme de Rambouillet.

Will the forest be praised for her new conduct? Not by me. She will find this most unfair, and one day, unable to stand it any longer, she will dump her trash in the heart of the nightingale. What will the nightingale say to that? The nightingale will be galled. 'My friend', he will reply, 'You are worth even less than your reputation. Go take a trip to Oceania, you'll see.'

And will she go? Too proud.

Do forests still exist there? They are, it seems, savage and impenetrable, black and russet, extravagant, secular, swarming, diametrical, negligent, ferocious, fervent and lovable, with neither yesterday nor tomorrow. From one island to another, over volcanos, they play cards with incomplete decks. Nude, they wager only their majesty and their mystery.

On the 24th of December, I am visited by a young chimera in evening dress.

1934. *Eight days later I meet a blind swimmer. . . . A little patience (fifteen days of waiting) and I will be present at the attirement of the bride. The bride of the wind embraces me while passing at full gallop (simple effect of touch).*

[Summer: Maloja, Switzerland, with Giacometti. Sculpts in stone. Publication of *Une Semaine de Bonté, ou les sept éléments capiteaux*, M.E.'s most ambitious collage novel.]

[M.E. told Roland Penrose later:] *All of these works suggest an overwhelming sense of motion through time and space. They vibrate with the incongruous and irrational qualities generally attributed to dreams although artists know they are the original breath of reality. The elements of the collages, banal engravings from old books, are metamorphosed, transformed. Birds become men and men become birds. Catastrophes become hilarious. Everything is astonishing, heartbreaking and possible.*

1935. *I see barbarians looking toward the west, barbarians emerging from the forest, barbarians walking to the west. On my return to the garden of the Hesperides I follow, with joy scarcely concealed, the rounds of a fight between two bishops. . . . Voracious gardens in turn devoured by a vegetation which springs from the debris of trapped airplanes. . . .*

With my eyes I see the nymph Echo.

1936. October: If you are to believe the description on his identity

card, M.E. would be no more than forty-five when he writes these lines. He would have an oval face, blue eyes and greying hair. His height would be only slightly more than average. As for distinguishing marks of identification, this card allows him none. Consequently he could, if pursued by the police, plunge into the crowd and easily disappear forever.

Women, on the other hand, find that his young face framed by silky white hair 'makes him look very distinguished'. They see in him charm, a great sense of 'reality' and seduction, a perfect physique and agreeable manners (the danger of pollution, he himself admits, has become such an old habit that he is rather proud of it as a 'sign of worldliness'). They find, also, a character difficult, inextricable, obstinate; also an impenetrable mind. 'He is,' they say, 'a nest of contradictions,' at once transparent and enigmatic, something like the pampas.

It is difficult for them to reconcile the gentleness and moderation of his expression with the calm violence which is the essence of his thought. They readily compare him to a gentle earthquake which does no more than rock the furniture yet does not hurry to displace everything. What is particularly disagreeable and unbearable to them is that they can almost never discover his *identity* in the flagrant (apparent) contradictions which exist between his spontaneous behaviour and the dictates of his conscious thoughts. For instance, they can observe two apparently irreconcilable attitudes: first, that of the god Pan and the man Papou, who possess all the mysteries and in their interplay realize a union ('He marries nature, he pursues the nymph Echo'); and, second, that of a Prometheus, thief of fire, conscious and organized, who, guided by thought, pursues with implacable hate and gross injuries. 'This monster is pleased only by the antipodes of the landscape,' they say. And a teasing little girl adds, 'He is, at the same time, a brain and a vegetable.'

[Meets the painter Leonore Fini. Ignoring Breton's veto, M.E. participates in exhibition *Fantastic Art, Dada, Surrealism*, Museum of Modern Art, New York, autumn, 1936, with 48 works, almost twice as many as any other exhibitor.]

1937. [Publication by Cahiers d'Art of *Au delà de la Peinture*, devoted to M.E.'s work from 1918 to 1936.] *I dedicate this book to Roland Penrose, to the nymph Echo and to the antipodes of the landscape.*

[Decors for *Ubu Enchaîné*, a play by Alfred Jarry directed by Sylvain Itkine. First presented by the Compagnie du Diable Éclarte at the Comédie des Champs-Elysées, Paris, September 22.]

[Meets the painter Leonora Carrington.]

1938. Enraged by a monstrous demand, 'to sabotage in every possible way the poetry of Paul Eluard', M.E. quit the surrealist group.

[With Leonora Carrington settles at Saint Martin d'Ardèche, near Pont St. Esprit about thirty miles north of Avignon. Decorates their home with murals and bas-reliefs. Illustrates and, with the following text, in part introduces her novella *La Maison de la Peur*. Loplop speaks:]

Good wind, ill wind, I present you the Bride of the Wind. . . . Who is the Bride of the Wind? Can she read? Can she write in French without making mistakes? What fuel keeps her warm? . . . She is kindled by her intensity, her mystery, her poetry. She has read nothing, yet she has drunk everything. She knows not how to read. Nevertheless, the nightingale saw her, seated on the stone of spring, reading. And, although she read in silence, animals and horses listened rapt with admiration.

1939. [War is declared. Paints *A Moment of Calm*. Interrupted.] 'He is under the jurisdiction of the German Reich.' As an enemy alien, M.E. was interned: first for six weeks in a camp at Largentière, then transferred to Les Milles near Aix-en-Provence. Liberated at Christmas time, thanks to a petition by Eluard to Albert Sarrault, M.E. returned to Saint Martin. Survived on subsidies sent him by his friend Joë Bousquet.

1940. May: Interned again; first in a camp at Lorio, then transferred to the St. Nicholas (!) camp near Nîmes. Escaped to Saint Martin, recaptured, interned again, escaped again just as his papers for release arrived. Allowed to return, once more, to Saint Martin. [Now, sought by the Gestapo, M.E. begins to paint *Europe after the Rain*. Decides to leave Europe.] An offer of shelter secured in the United

States by several friends including Marga Barr, son Jimmy, expedited through the Emergency Rescue Committee by Varian Fry.

1941. [On his way, at Marseille, M.E. meets Breton also seeking a way to leave. Attempt at reconciliation. Meets Peggy Guggenheim. Because of complications with his transit visa, M.E. has trouble leaving France but finally crosses the border to Madrid and leaves, with Peggy Guggenheim, from Lisbon.]

July: M.E. arrived in New York at the La Guardia airport where his son Jimmy welcomed him to the United States. From the plane he had glimpsed the lovely lady, the Statue of Liberty. Hardly off the plane he was seized by immigration authorities. 'He is under the jurisdiction of the German Reich.' Interned in the fortress of Ellis Island—had a splendid view of the Statue of Liberty. Liberated after three days, M.E. travelled for several weeks across the United States—Chicago, New Orleans, Arizona, New Mexico, California. [Decides to settle in New York.]

First painting in America: *Napoleon in the Wilderness*. The decalcomania base was begun in France, but the painting was finished in Santa Monica, shortly after M.E.'s arrival. (He had just quit Europe: Napoleon—the dictator; wilderness—Saint Helena; exile—defeat, and so forth. The painting, he discovered, bore a strange likeness to an allegory by Piero di Cosimo in the Kress Collection.) About a month later when M.E. visited the National Gallery in Washington, he was amazed to see the resemblance in *idea* between this picture, which he had never seen before, and his own painting—the strange horse dancing, the guardian winged female figure, the string and, in the foreground, the sea monster.

Loplop, Bird Superior, had followed the airplane which brought me to this country on the fourteenth of July, and the bird builds his nest in a cloud on the East River.

[Marries Peggy Guggenheim. They separate at the close of the following year.]

In New York, on Wall Street, M.E. enjoyed the way they pronounced his name and added it to his collection. Here it is: Mac, Maxt, Mex, Mask, Oinest, Oinst, and so forth.

1942 Exhibitions in New York, Chicago and New Orleans, complete 'flops'. The press hostile (or silent), the public recalcitrant (sales nil), and so forth. Compensation: Young painters and poets were enthusiastic.

In the same year, the non-Euclidian fly appears.

[At the Wakefield Bookshop, New York, Betty Parsons shows in a group exhibition a painting by M.E.] It provoked the curiosity of some of the young painters. The technique especially intrigued them. M.E. explained: It is a children's game. Attach an empty tin can to a thread a metre or two long, punch a small hole in the bottom, fill the can with paint, liquid enough to flow freely. Let the can swing from the end of the thread over a piece of canvas resting on a flat surface, then change the direction of the can by movements of the hands, arms, shoulder and entire body. Surprising lines thus drip upon the canvas. The play of association then begins.

[This particular painting, slightly altered by M.E., becomes *Young Man intrigued by the flight of a non-Euclidian fly*, now in a private collection in Zurich. The magazine *View* devotes an issue to M.E., M.E. collaborates on the founding of the magazine *VVV*.]

1943. *Within the realm of the possible, at last, a gathering.* [M.E. meets the painter Dorothea Tanning. They spend the summer in Arizona.]

[Sidney Janis in his *Abstract and Surrealist Art in America*, published the following year, writes: 'In his American pictures, as in the past, Max Ernst continues to invent new techniques with which he creates the properties of enigma that inevitably fill his work. He has recently invented a new method of chance—oscillation—and in this technique has painted several large gyrating compositions. They are produced by means of colour flowing freely from a swinging container operated with a long cord by the artist. Ernst in several recent works has combined techniques as well as images from many periods. These are compartmentalized by horizontal and vertical lines which divide them into rectangular segments somewhat resembling the spatial order of Mondrian. *Day and Night* [1942], painted previously, anticipated this trend. One of these pictures, *Vox Angelica* [1943] is an autobiographical account in

episodes of dream and reality, of his peregrinations from one country to another.']

1944. Summer: M.E. found himself working steadily at sculpture. He had rented a place at Great River, Long Island, with the intention of spending the summer swimming. But there were so many mosquitoes that we could not poke our noses out of doors. Decided to take over the garage, screen it and make a studio. There he worked the summer on sculpture.

1945. [Invited by Albert Lewin, M.E. enters and wins a competition sponsored by Loew-Lewin for a painting on the theme of *The Temptation of St. Anthony* used in the film *The Private Affairs of Bel Ami*, based on Maupassant's story.]

[Eluard organizes a retrospective exhibition in honour of M.E. at the Galerie Denise René, Paris.]

1946. Double Wedding in Beverly Hills: M.E. and Dorothea, Man Ray and Juliette Browner. [M.E. and Dorothea Tanning find a temporary retreat in the mountains of Arizona; in Sedona they acquire a piece of land and begin to construct a house. During a stay in the Nevada desert, composes *Sept microbes vus à travers un temperament.*]

1947. Sedona, Arizona: building, sculpting, painting, writing, and-last (not least) loving (Dorothea).

[*A l'intérieur de la vue-8 poèmes visibles,* poems by Eluard as illustrations to collages by M.E.]

1948. [*Beyond Painting,* by and about M.E., edited and with an introduction by Robert Motherwell. M.E. becomes a United States citizen.]

1949. [Retrospective exhibition organized at Copley Galleries, Beverly Hills. On the occasion of the exhibition, the gallery publishes as one volume *At Eye Level/Paramyths,* about and by M.E., Marcel Duchamp visits Sedona. August: Sails from New Orleans to Antwerp, then by train to Paris.]

With Dorothea saw Paris once more-mixed feelings-Paris and its inhabitants slowly, painfully recovering from Nazi occupation, frustration and disorder.

M.E. was glad to greet his old friends: Arp, Joë Bousquet, Patrick Waldberg, Robert Lebel, André Pieyre de Mandiargues, Georges Bataille, Giacometti, Balthus, Penrose. Also Paul Eluard, in spite of some difficulties (the poet of freedom caught by a merciless discipline).

[*La Brebis Galante* by Benjamin Péret with illustrations by M.E. published. The bookstore La Hune, Paris, celebrates the event with a retrospective exhibition of the graphic work of M.E.]

1950. M.E.'s devoted friend, François Victor Hugo, provided him with a studio on the Quai St. Michel across the river from Notre Dame de Paris.

[Retrospective exhibition organized at the Galerie René Drouin, Paris. Catalogue: preface by Joë Bousquet and text by Michel Tapié. The exhibition shows, for the first time in Paris, M.E.'s work done in America. October: Returns to Sedona.]

1951. [Loni and Lothar Pretzell, sister and brother-in-law of M.E., organize a large retrospective exhibition at the ruined castle of the archbishops of Cologne at Brühl.] A bolt of lightning destroyed a banner bearing M.E.'s name. This incident considered an omen from the heavens by the inhabitants of the town; the town council met during the night; the exhibition ended with a huge deficit for the city administration and with the disgrace of the very understanding and very well-intentioned *Stadtdirektor,* personally accused of responsibility for the financial disaster. [This exhibition at Brühl, had considerable influence in the Rhineland, still recovering from Nazi suppression of all modern art.]

1952. [March: Yves Tanguy visits Sedona. During the summer M.E. conducts a course of about thirty lectures at the University of Hawaii, Honolulu. Subject: The last fifty years of modern art. About ninety-six students-corrects their examination papers. Also gives one general lecture on surrealism. In Houston, at the Contemporary Art Association, Dominique de Menil, aided by A. Iolas, organizes an exhibition of M.E.'s work.]

1953. [M.E. returns to Paris. Works in the Impasse Ronsin, next to Brancusi, in a studio lent to him by the painter William Copley.

Retrospective exhibition organized by E.L.T. Mesens and P.G. van Hecke (with collaboration of the Institute of Contemporary Arts, London) at the Municipal Casino, Knokke-le-Zoute, Belgium. *Das Schnabelpaar,* a poem and eight etchings in colour by M.E. published.]

[Fall: Visits Cologne, the Rhineland and Heidelberg.] M.E. had not seen Cologne for twenty-five years. Naturally it was a terrible shock to him. Nothing remained of the city, every stone of which he had known. When reconstruction of the Town Hall was begun, they found an old Roman villa, perfectly preserved. It was fantastically luxurious, and with a (modern!) system of central heating through the floor.

1954. At the Twenty-seventh Biennale of the City of Venice, M.E. to his astonishment grabbed first prize.

1955. [Settles in Huismes in Touraine near Chinon. *Galapagos* by Antonin Artaud with illustrations by M.E. published.]

1956. [At a shop in Chinon finds border strips of old-fashioned wallpapers similar to those he had used more than thirty-five years before and, for his amusement, makes a series of collages: *Dada Forest, Dada Sun.* Retrospective exhibition organized at the Kunsthalle, Berne, catalogue preface by Franz Meyer.]

1957. [Winter, 1956-57: Sedona. At the Museum of Tour, an exhibition with Man Ray, Dorothea Tanning and Mies van der Rohe sponsored by Les Services des Relations Culturelles de l'Ambassade des Etats-Unis.]

1958. [Becomes a French citizen. Patrick Waldberg's biography, *Max Ernst,* published. The bookstore La Hune celebrates the event with an exhibition.]

Spring: M.E. was astonished when he was informed that the Museum of Modern Art in New York wished to organize an exhibition of his work.

1959. [November: A large retrospective exhibition of his work opens at the Musée d'Art Moderne. Catalogue edited by Gabrielle Vienne, preface by Jean Cassou.]

1960. [Autumn: Trip to Germany with Patrick Waldberg. *Max Ernst* with texts by M.E., preface by Georges Bataille published.]

1961. January: M.E. arrived in New York with the intention of visiting Sedona, an exhibition at the Museum of Modern Art and, perhaps, his grandchildren. He reread (with interest) this dated data, a chronology unchronologically composed. In it he found things old, things new (and some things censored). It is, he decided, to be read in English by other friends, some new, some old, all young.

MAX ERNST, 23 January, 1961, New York

This account may be extended with the following brief notes covering the years since 1961:

1961. Exhibition of sculpture at the Galerie Le Point Cardinal in Paris. Retrospective at the Tate Gallery in London.

1963. Large exhibitions at the Wallraf-Richarts Museum in Cologne and the Kunsthaus in Zurich. Exhibition of *Ecrits et œuvre gravée* at the Municipal Library in Tours and at the Galerie Le Point Cardinal in Paris. Further exhibitions, of sculpture, in Helsinki, Stockholm, Lousiana Museum (Denmark), and the Grimaldi Museum in Antibes.

1964. Exhibition at the Iolas Gallery in Paris-*Cape Capricorne.*

1966. Again at the Iolas Gallery in Paris, *La musée de l'homme suivi de la pêche au soleil levant.* Exhibition *Au delà de la peinture* at the Palazzo Grassi in Venice, and *Sculpture and Recent Painting* at the Jewish Museum in New York.

1967. The City of Prague arranges an exhibition entitled *Ecrits et œuvre gravée.* This same exhibition was also later shown at Worpswede and at the Kunsthalle in Hamburg.

1968. *Le néant et son double* at the Iolas Gallery in Paris.

1969. The Iolas Gallery in Paris shows the *Journal d'un Astronaute Millénaire* from the 11th March to 12th April.

Bibliography

ARTIST'S WRITINGS

Vom Werden der Farbe, Der Sturm 8, No. 5: 66–8, Aug. 1917; *Visions de demi-sommeil*, La Révolution Surrealiste, No. 9–10: 7, 1st Oct., 1927; *Comment on force l'inspiration*, Le Surrealisme au Service de la Révolution, No. 6, 15th May, 1933; *Les mystères de la forêt*, Minotaure, No. 5–6, May, 1934; *Was ist Surrealismus?*, pp. 3–7 in Zurich, Kunsthaus Exhibition. Oct–Nov. 1934; *Au delà de la peinture*, Cahiers d'Art, No. 6–7, 1936; *Préface, ou Loplop présente la mariée du vent*, In Leonora Carrington, La Maison de la Peur, Paris, Parisot, 1938; *Beyond Painting, and Other Writings by the Artist and his Friends*, New York, Wittenborn, Schultz, 1948; *Notice biographique rédigée par l'artiste*, in Max Ernst (Catalogue), Paris, Musée d'Art Moderne, Nov.–Dec. 1959.

GRAPHIC WORKS

Les Malheurs des Immortels, Paris, Librairie Six, 1922; *Répétitions, Dessins de Max Ernst*, Paris, Au Sans Pareil, 1922; *Histoire Naturelle*, Paris, Editions Jeanne Bucher, 1926; *La Femme 100 Têtes*, Paris, Editions du Carrefour, 1929; *Rêve d'une Petite Fille qui Voulut Entrer au Carmel*, Paris, Editions du Carrefour, 1930; *Mr Knife and Miss Fork*, Paris, Black Sun Press, 1931; *Une Semaine de Bonté, ou Les Sept Elements Capitaux; Roman*, Paris, Editions Jeanne Bucher, 1934; *Le Château Etoilé*, Minotaure, Paris, 1936; *A l'Intérieur de la Vue–8 Poèmes Visibles*, Paris, Seghers, 1947; *La Brebis Galante*, Paris, Editions Premières, 1949; *La Chasse au Snark*, Paris, Collection 'L'Age d'Or', 1950; *Fiat Modes*, Paris, Collection 'L'Age d'Or', 1951; *Das Schnabelpaar*, Basle, Ernst Beyeler, 1953; *Sept Microbes, Vus à travers un Tempérament*, Paris, Cercle des Arts, 1953; *Galapagos–Les Iles du Bout du Monde*, Paris, Broder, 1955;

CATALOGUES AND MONOGRAPHS

Zervos, Christian, ed., *Max Ernst: Œuvres de 1919 à 1936*, Paris, Editions Cahiers d'Art, 1937; *View (Max Ernst Number)* Paris, Galerie Denise René, *Max Ernst*, 1945; Copley Galleries, Beverley Hills, Calif., *Max Ernst, 30 Years of his Work, A Survey*, 1949; Paris, Galerie René Drouin, *Max Ernst: Textes de Joë Bousquet et Michel Tapie*, 1950; Pretzell, Lothar & Pretzell, Loni ed., *Max Ernst: Gemälde und Graphik*, 1920–50, (Stuttgart, Kohlhammer, 1952); Knokke-le-Zoute, Albert Plage, Casino Communal, *Max Ernst*, Brussels, Editions de la Connaissance, 1953; Berne, Kunsthalle, *Max Ernst*, 1956; Eduard Trier, *Max Ernst*, Cologne, Seemann, 1956; Patrick Waldberg, *Max Ernst*, Paris, Pauvert, 1958; Paris, Musée d'Art Moderne, *Max Ernst*, Paris, Editions des Musées Nationaux, 1959; Pierre Seghers, ed., *Max Ernst*, Paris, Gonthier-Seghers, 1959; Cologne, Galerie der Spiegel, *Hommages à Max Ernst*, 1960; London, Tate Gallery, *Max Ernst*, 1961; New York, World House Galleries, *Max Ernst: two eras*, 1961; New York, Museum of Modern Art, *Max Ernst*, ed. W. S. Liebermann, 1961; Tours, Bibliothèque Municipale, *Max Ernst: écrits et œuvre gravée*, 1963; London, Hanover Gallery, *Max Ernst: early and recent painting and sculpture*, 1965; John Russell, *Max Ernst: Life and Work*, London, 1967; Paris, Galerie Le Point Cardinal, *Max Ernst: œuvre sculptée, 1913–61*, 1961; Werner Spies, *Max Ernst: frottages*, London, 1969.

GENERAL

Hans Arp, *Onze Peintres vus par Arp*, Zurich, Girsberger, 1949; Alfred Barr, Jr., *Fantastic Art, Dada, Surrealism. Essays by Georges Hugnet*, 3rd ed., New York, Museum of Modern Art, 1946; André Breton, *Les Pas Perdus*, Paris, Gallimard, 1924; Hugh Edwards, *Surrealism and its Affinities*, Chicago, Art Institute of Chicago 1956; Carola Giedion-Welcker, *Contemporary Sculpture*, New York, Wittenborn, 1955; Peggy Guggenheim, *Confessions of an Art Addict*, New York, Macmillan, 1960; Georges Hugnet, *L'Aventure Dada (1916–22)*, Paris, Galerie de l'Institut, 1957; René Huyghe ed., *Histoire de l'Art Contemporain: La Peinture*, Paris, Alcan, 1935; Sidney Janis, *Abstract and Surrealist Art in America*, New York, Reynal & Hitchcock, 1944; Marcel Jean, *History of Surrealist Painting*, New York, Grove, 1960; *Looking at Modern Painting*, Los Angeles, University of California, 1957; Robert Motherwell ed., *The Dada Painters and Poets: an Anthology*, New York, Wittenborn, Schultz, 1951; Librarie Nicaise, (Catalogue No. 10). *Cubisme, Futurisme, Dada, Surréalisme*, Paris, 1960; Maurice Raynal (and others), *History of Modern Painting. (Vol. 3): From Picasso to Surrealism*, Geneva, Skira, 1950; Andrew Ritchie ed., *German Art of the Twentieth Century* by Werner Haftmann, Alfred Hentzen, William S. Lieberman, New York, Museum of Modern Art, 1957; Hans Vollmer, *Allgemeines Lexikon der bildenden Künstler des XX Jahrhunderts*, Vol. 2, Leipzig, Seemann, 1955.

ARTICLES IN PERIODICALS

Alain Bosquet, *Le bonheur de Max Ernst*, Quadrum (Brussels) No. 5, 1958; Pierre Cabanne, *Max Ernst*, Arts (Paris) No. 793, 26th Oct.–1st Nov., 1960; Cyril Connolly, *Surrealism*, Art News (New York), Nov. 1951; Jacques Dupin, *Les dernières peintures de Max Ernst*, Cahiers d'Art (Paris) 28, No. 1, 1953; Max Ernst, *Souvenirs rhénans*, L'Œil, No. 16, April, 1956; Alain Jouffroy, *Max Ernst, un indépendant . . .*, Arts (Paris) No. 537, Oct. 1955; Also *Kunsten Idag* (Oslo) No. 4, 1959 (with French translation), and an interview (Arts, No. 756, Jan. 1960); André Pieyre de Mandiargues, *Max Ernst*, Art International (Zurich) 4, No. 1, 1960; Hans Richter, *Max Ernst, La Biennale di Venezia*, Nos. 19–20, April–June 1960; Also: *A propos de Max Ernst et de 'La Semaine de Bonté'*, Style en France (Paris) No. 4, 1946; Jean Schuster, *Interview with Max Ernst on Germany*, Medium No. 2, Feb. 1954; René de Solier, *Papiers collés surréalistes*, XXe Siècle (Paris) No. 6, Jan, 1956; Heinz Spielmann, *Notizen über Max Ernst und Herkules*, Das Kunstwerk (Baden-Baden) No. 8, Feb. 1960; James Johnson Sweeney, *Eleven Europeans in America: (Max Ernst)*, Museum of Modern Art Bulletin, Nos. 4–5, 1946; Patrick Waldberg, *Max Ernst*, Cahiers d'Art (Paris) No. 2, 1949; Also essays on the artist appearing variously in Mercure de France (No. 1126, 1957), XXe Siècle (Paris) No. 8, Jan. 1957, and No. 10 and No. 11, 1958. Hilde Vogel, *Max Ernst Ausstellung in Venedig*, Echo der Zeit, 23 October 1966; J. P. Hodin, *Italien-Venedig-Max Ernst*, Die Kunst und die schöne Heime, October, 1966; Arthur Kleb, *Il pittore e scultore Max Ernst, Italturismo*, Venezia, July 1966; Norbert Lynton, *Max Ernst Exhibition in Venice*, The Guardian, Manchester, 5th August, 1966; Pierre Descargues, *Max Ernst–Au delà de la peinture*, La Tribune de Lausanne, 21st June, 1966.

3.95